The Kew Book
of
BOTANICAL
ILLUSTRATION

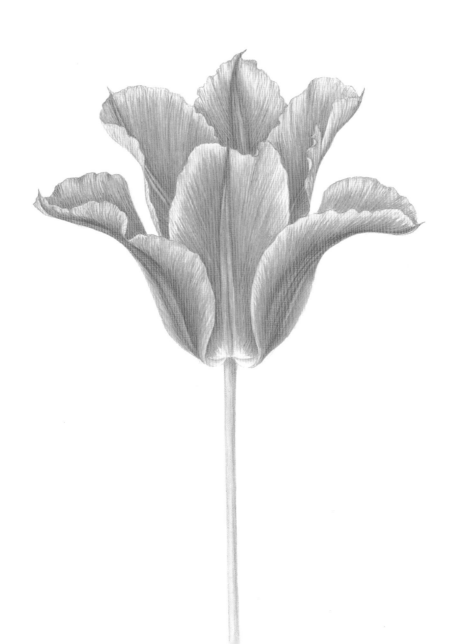

Foreword

I am so pleased that Christabel King has produced a book about her forty years of expertise in botanical illustration. She is one of the foremost botanical illustrators of today. She is also a wonderful teacher who has trained many other illustrators. When I travel in Brazil, I meet so many talented young artists who learned their skills from Christabel. She has been generous with her time in order to share her knowledge and expertise with other people from several different countries. Christabel has traveled a lot to teach and to produce some of her paintings and sketches from living material in the field. I treasure a painting of *Qualea* that she did for me on her trip to the Amazon region. This species is related to the beautiful blue-flowered *Erisma calcaratum* shown on page 102, where the blue is so accurately portrayed. It is great that many of the secrets of her success as an illustrator are revealed here in a book that will help many budding botanical artists. Her dual training in both botany and art show here and in all of her work. It is quite fascinating to read the many skills and techniques that are needed to be a good illustrator of plants. You can use this book to learn to be an illustrator, but it is also a volume that you can just sit back and enjoy. It includes many of her colour paintings for the famous *Curtis's Botanical Magazine*, grouped under such interesting categories as endangered plants, economic plants orchids, and plants in horticulture. Plant lovers will want to browse in this book whether or not they are aspiring illustrators. It is fine artists like Christabel King that have enabled Curtis to continue publishing continuously since 1787.

Professor Sir Ghillean Prance FRS, VMH

Professor Sir Ghillean Prance is a prominent British botanist and ecologist; former Director of the Royal Botanic Gardens, Kew; former Director of the Institute of Economic Botany and Senior Vice President for Science at The New York Botanical Garden; and Director of Science at the Eden Project in Cornwall.

The Kew Book *of* BOTANICAL ILLUSTRATION

CHRISTABEL KING

SEARCH PRESS

ROYAL BOTANIC GARDENS

First published in Great Britain 2015

Search Press Limited
Wellwood, North Farm Road,
Tunbridge Wells, Kent TN2 3DR

ISBN 978 1 84448 947 3

The Publishers and author can accept no responsibility
for any consequences arising from the information,
advice or instructions given in this publication.

Suppliers

If you have any difficulty obtaining any of the materials
and equipment mentioned in this book, please visit the
Search Press website:

www.searchpress.com

ACKNOWLEDGEMENTS

Many thanks to Paul Little for photography, to Roger and
Diana Polhill for use of the picture of *Dendrosenecio adnivalis*
on page 101, which will feature on the cover of their book on
East African Plant Collectors, distributed by
Kew Publishing, and to Nicole Potulski for use of the picture
of a piece of chalk turf on page 96.

DEDICATION

This book is dedicated to all those who enjoy botanical
art and illustration.

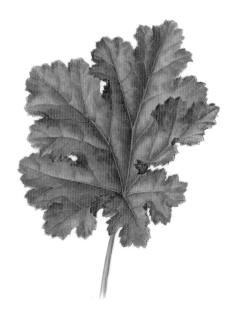

Page 1:
***Tulipa* cv. 'Ballerina'**
See also page 123.

Page 3:
Rhodohypoxis baurii var. confecta
Working drawing. See also page 23.

Opposite:
Rosa chinensis forma spontanea
Plate 539, Vol. 22(4), 2005
This vigorous wild rose from North West China is
probably one of the ancestors of modern garden roses.
See also page 105.

Printed in China

Contents

INTRODUCTION

I HAVE BEEN MAKING ILLUSTRATIONS FOR KEW GARDENS, or to give it its proper name, the Royal Botanic Gardens, Kew, since 1975, but the challenge of writing a book about it made me think about the different perspectives on what is called botanical illustration. We might make a distinction between botanical illustrations, which are made to accompany text, and botanical art, which includes other representations of plant subjects. However, if strictly interpreted, this would disqualify techniques more used for botanical art than illustration, but which would be of interest to include. So as well as the usual techniques of line drawing and watercolour used for Kew publications, I have included some techniques and examples not intended for publication. When working on highly detailed illustrations, it is restful to take time off to work on something different. In any case, botanical art has a certain poetic element which may be lacking in scientific botanical illustration, and it is this which is needed to capture the indefinable quality of beauty.

Most people know the Royal Botanic Gardens, Kew as a botanical garden where the public can see and enjoy plants from all over the world in cultivation. The sheer number and variety of trees, shrubs and herbaceous plants, growing outside and under glass, mean that there will always be some new plant not seen before to find on a visit. But besides the well-known collections of living plants, there is also a very large collection of pressed and dried plant specimens from all over the world in the Herbarium, which is not generally open to the public. This is where work to increase knowledge of the world's flora is done. The pressed specimens lose their colour but keep all their botanical features, and most of the botanical illustrations made for Kew publications are line drawings made from these.

However, there is one publication for which coloured illustrations are used, which is *Curtis's Botanical Magazine*. This is the longest running periodical of its type, having been produced since 1787 to record and describe plants in cultivation in British gardens. There is a section about the Magazine later in the book, where the requirements of these illustrations are described.

Many years ago I drew this group of wild flowers of the Burren, an interesting area of limestone pavement in County Clare, Ireland, which is now within a Special Area of Conservation. Plants may no longer be picked or collected there. If you like drawing plants growing in soil, the solution is to establish an area for wild flowers in your garden. A group like this could be grown on a rock garden with limestone chippings, or in a container so that it could easily be brought inside for drawing.

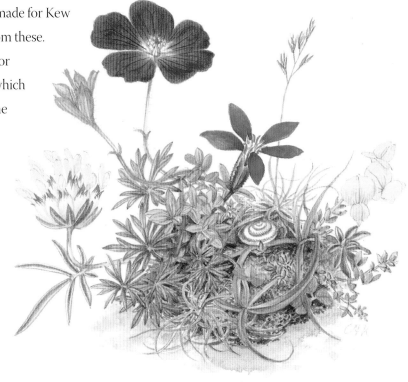

I have had the privilege of contributing illustrations since 1975 and hope to continue, as it gives plenty of opportunity to have a close look at living plants, make full-colour illustrations and explore their structure in dissections.

The painting and drawing techniques described in this book were mostly learned during a course in Scientific Illustration at Middlesex Polytechnic (now University), but before this I had done a first degree in Botany at University College, London, so my approach to drawing was influenced more by science than art. When I began to make illustrations for publication, I learned from Kew botanists how various conventions are used in scientific botanical illustration, to make drawings of floral dissections which are clear and easy to interpret. The editor of *Curtis's Botanical Magazine* patiently trained me to produce illustrations in the way that previous artists had done. Help was needed while I learned how a plant could be illustrated at natural size in the narrow page format of the Magazine and what should be included or left out. This is the difference between making a picture for pleasure and making a scientific illustration. Artists' licence can only be used in certain respects, but it is better to avoid changing anything if possible, because nature knows best.

The publication of plant species new to science is a sought-after opportunity for botanists and sometimes illustrators have the interesting job of drawing them. The more familiar species of wild flowers and garden plants may have been illustrated many times already but the world's flora remains new for each person to discover and enjoy drawing. Time spent looking at plants reveals their beauty and is usually a rewarding experience.

Iris bloudowii
Plate 577 from *Curtis's Botanical Magazine* Vol. 24(1) 2007.

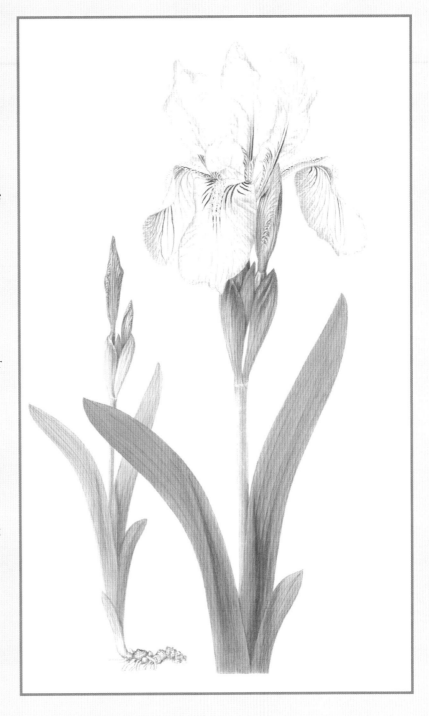

Botanical illustration

Knowledge about plants and their uses is as old as the human race. Animals know by instinct how to find their food and what to eat if they feel ill, but humanity eventually demanded more than instinctive knowledge to improve life, and when writing came into use, traditional knowledge could be transmitted as written records. One of the earliest texts about plants is the Ebers Papyrus on ancient Egyptian herbal medicine. Dated to about 1500 BC, it is said to contain material from as long ago as 3000 BC because of references to earlier dynasties in Egyptian history. The herbalists of the time would probably have grown up with knowledge of the vernacular plant names of the local tradition, but did not use illustrations. The idea of providing an illustration to clarify the identity of a plant is attributed to a Greek called Krateuas (120–60 BC), who was court doctor to the Persian king Mithridates of Pontus. He produced a series of painted illustrations for his treatise *Rhizotomikon* with the name and medical properties of each plant written under the image of the plant. These illustrations were eventually incorporated in the famous herbal of Dioscorides called *De Materia Medica* which was the standard textbook of herbal medicine for a thousand years and was copied over and over again.

An illustration with a name was a useful aid to finding and identifying a plant and passing on the traditional lore associated with it. However, an illustration of one plant does not record the range of variation, perhaps of flower colour or shape and size of leaves. The combination of an illustration and a verbal description provides more information and this is what is used today in scientific botanical literature. An illustration normally includes a life-size habit drawing (a drawing of a representative portion of a plant), often made from a pressed herbarium specimen, together with enlarged details of the flowers, fruits and any other features which are important in distinguishing it from similar species. The accompanying description gives measurements and numbers of parts, also geographical distribution and other names by which the plant may have been known, together with references to where it had previously been published. It is interesting that as long ago as classical times, importance was put on stating sources of information and authors whose works were being quoted. Some of the early philosophers such as Thales and Theophrastus made their own first-hand observations and even carried out experiments. The foundations of the present-day approach to scientific information based on careful observation and experiment were already there. However, it took until the Renaissance for botany to become a subject for study in its own right, apart from its medical and agricultural aspects.

The rival method of recording plants is photography. This delightfully easy way of making a record of a plant is now taken for granted. It is fast and convenient for gathering illustrations for books, which can then be produced quickly. With digital photography, everything seems possible under almost any conditions, and one wonders if there is any need to continue making illustrations by hand. The answer to this is definitely 'yes', because although software makes almost anything possible for improving and editing a photograph, a line drawing can still be made quite quickly, is clearer in selecting which details to show and can be included in the text at less cost. Where colour is not necessary, a line drawing is cheaper and more effective. Coloured illustrations such as those made for *Curtis's Botanical Magazine* might seem to be a luxury, but if there is an enthusiastic audience for them, either as works of art or as useful illustrations, people will continue to produce them. One hopes that this long tradition, with its links to the beginnings of scientific enquiry in classical times, will continue to promote people's interest in botany and the fascinating world of plants around them.

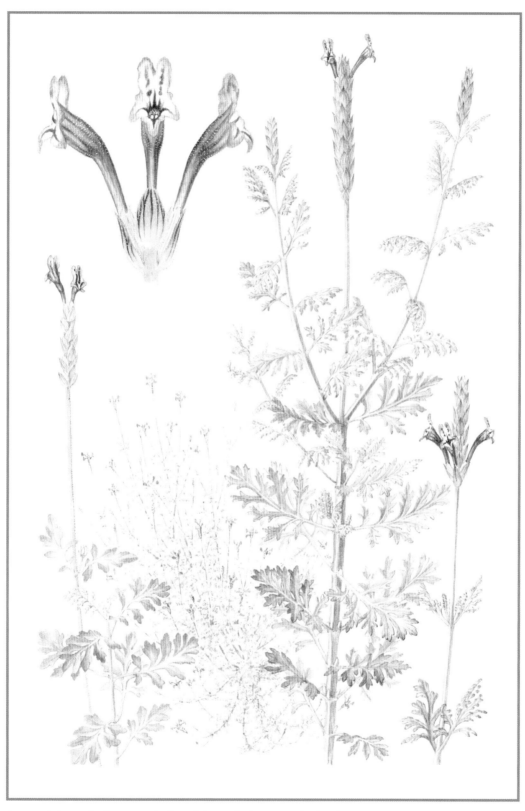

Lavandula mairei var. mairei and *L. mairei var. antiatlantica*

Artwork for Plate 24 from *The Genus Lavandula* by Tim Upson and Susyn Andrews (Royal Botanic Gardens, Kew, 2004).

Materials

Good quality equipment and materials are definitely a help in achieving a high standard of technical skill in whatever medium you are using. Of all the materials, the quality of the brushes is the most important because it is almost impossible to paint well with a bad brush. Some suppliers will allow testing of watercolour brushes in water before purchase, to ensure that they come to a fine point. Paints are the next in importance when it comes to quality. It is better to have a few high-quality colours than a wide range of less useful, lower quality paints.

Pencils

Good quality graphite pencils, grades 3B to 4H.

Knife for sharpening.

Clutch pencil for 2mm leads in the above grades.

Rotating sharpener for clutch pencil.

Emery paper, fine grade, for keeping points sharp.

Soft plastic eraser.

Fine eraser in a holder.

Pen and ink

Rapidograph (a technical pen that controls the ink flow).

Dip pen with Hiro Leonhardt 6H or 700 nib.

Dip pen with Gillott 303 or 290 nib.

Mapping pen.

Ink specifically for rapidographs.

Winsor & Newton black waterproof ink.

Daler Rowney FW acrylic ink.

Paper

Cartridge paper spiral-bound sketchbook.

Tracing paper.

Layout paper.

Line drawing paper.

Watercolour materials

Watercolour paper, smooth surface, 300gsm (140lb) or more.

Spiral-bound watercolour pad.

Glued block of watercolour paper.

Artists' quality watercolour paints in tubes or pans (see opposite).

Paint box for pans.

Plastic folding palette for tubes.

Best quality round sable brushes.

Miniature sable brushes.

A selection of watercolour paints

There are many colours to choose from but the following are useful for botanical illustration. Most are from the Winsor & Newton range of artists' quality colours except for those made by Schmincke (7) and Daniel Smith (2,11).

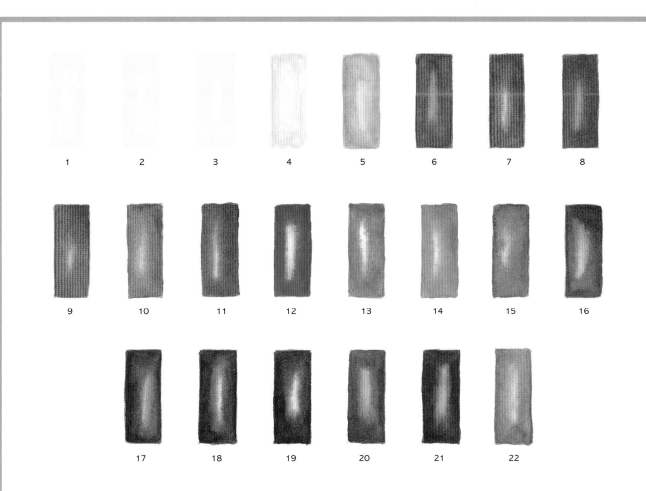

1 Cadmium lemon: A strong, pale yellow for making green.

2 Hansa yellow light (Daniel Smith): Similar to 1 but more transparent.

3 Aureolin: A transparent and lightfast yellow.

4 Cadmium yellow: Useful for centres of flowers.

5 Cadmium orange: Makes olive greens if mixed with blue.

6 Scarlet lake: Gives a warm pink when diluted.

7 Ruby red (Schmincke): Gives a brighter pink than permanent rose.

8 Permanent alizarin crimson: more lightfast than the old colour.

9 Permanent rose: A cool pink.

10 Permanent magenta: A mauve, also useful in shadow colours.

11 Carbazole violet (Daniel Smith): A new colour which seems to be lightfast.

12 French ultramarine: A strong, purplish blue.

13 Cobalt blue: A permanent, clear blue.

14 Winsor blue (green shade): Useful for fresh greens for young leaves.

15 Indanthrene blue: A new colour; a strong, dark blue.

16 Indigo: A dark grey-blue useful for making green.

17 Payne's gray: For very dark greens.

18 Neutral tint: Makes good pale greys.

19 Lamp black: For monochrome paintings.

20 Sepia: A strong, cool, dark brown.

21 Perylene maroon: For reddish tints on leaves and stems.

22 Raw umber: A pale golden brown for dead leaves.

Gouache materials

White ceramic tile for use as
a palette.
Palette knife.
Round brushes of the type used
for acrylics.
Small artificial fibre brushes for
fine details.
Large 2.5cm (1in) flat brush for
tinting paper.
Watercolour paper, HP smooth surface,
300gsm (140lb) or more.
Coloured mounting board (to paint on
if liked).

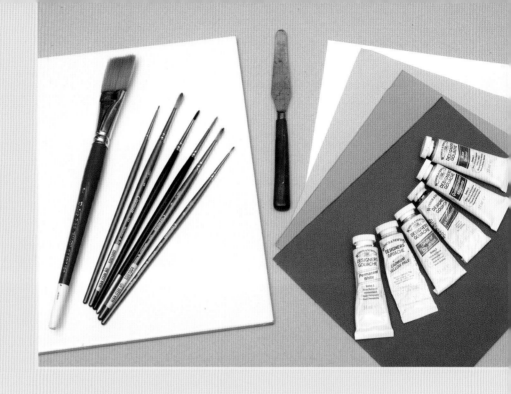

Gouache paints

Gouache colours are more or less opaque, water soluble and mixable with watercolours.
The following selection are listed as durable or permanent in the Winsor & Newton range.

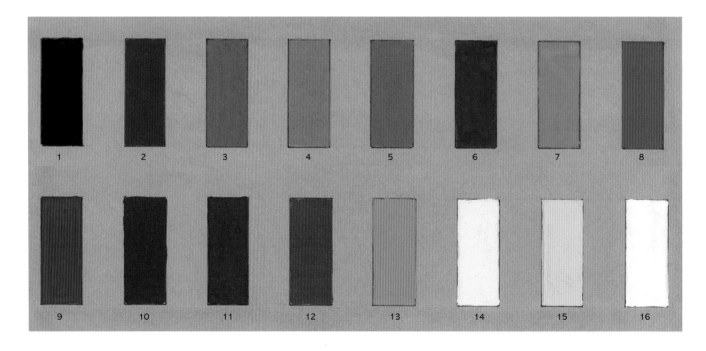

1	Lamp black	7	Cerulean blue	13	Cadmium orange
2	Vandyke brown	8	Cobalt blue	14	Cadmium lemon
3	Raw umber	9	Ultramarine	15	Naples yellow
4	Yellow ochre	10	Quinacridone magenta	16	Permanent white
5	Oxide of chromium	11	Permanent alizarin crimson		
6	Winsor green	12	Cadmium red		

Minimum materials for beginners

If you want to buy the minimum in order to try out botanical painting, the following will be enough to start with:

2H and HB pencils.
Sharpener.
A piece of fine emery paper to keep the point sharp.
A plastic eraser.
Sable watercolour brushes, for example sizes fine (0), medium (2–4), large medium (4–6).
Watercolour paints.
Smooth surface watercolour paper.
A plastic palette.

It is better not to economise on brushes as it is very difficult to paint with a bad brush, meaning one which will not come to a point and which does not spring back into shape when wet. Artists quality paints are also worthwhile as it is difficult to get sufficient colour from poor quality paints.

Other materials

Dividers for checking size and proportion.
Proportional dividers for reduction or magnification.
Ruler for drawing guidelines and measuring.
Craft knife for cutting and for removing mistakes.
Razor blade for cutting plant sections.
Burnisher for smoothing roughened areas after corrections.
Removable adhesive tape for attaching paper to a board.
Kitchen paper for cleaning the palette.
Mounted needle and forceps for making floral dissections.
Containers for keeping plant material fresh.
Floral foam or clamp on a stand for fixing plant in position.
Fixative spray for pencil drawings.

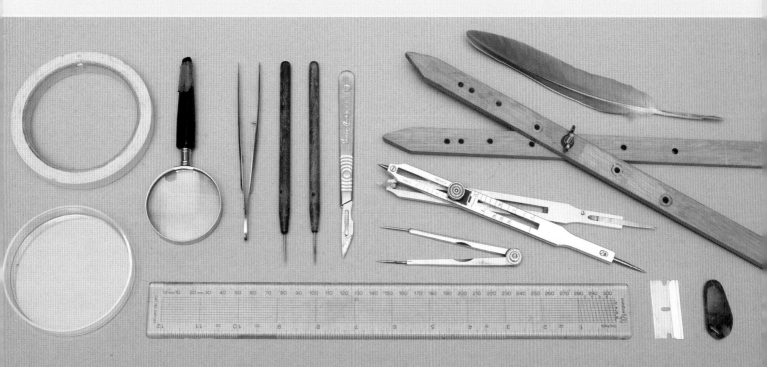

Choosing the subject

Choosing the subject for a drawing or painting is an important part of the creative process. Selecting a good example of the plant you are going to paint is the first step towards a good illustration. If you do not choose well, the result can be disappointing. Looking at plants from the point of view of whether or not they would make a good painting develops the faculty of visualising the painting you could make. This is a skill that grows with experience and the more you do it, the easier it will be.

If someone has asked you for an illustration of a particular plant, the problem of choice is already solved. If not, the first thing to do is make a list of plant names from any ideas which occur to you. This will help you to think out your options. Consider each plant from the point of view of how long it will take, how big the illustration will be, how easy it is to get material and whether it will last well in water. Then the choice may be easier.

The subject for drawing is likely to be either a florists' flower, a garden flower or a wild flower.

Florists' flowers

These are usually highly bred for decorative use and tend to be somewhat artificial looking, with more petals than usual and selected deformities to catch the eye. They can make good subjects for paintings but are unrewarding for analytical dissections.

Garden flowers

These may also have been selectively bred for display, but are often exotic wild flowers from abroad, cultivated for their beauty or botanical interest.

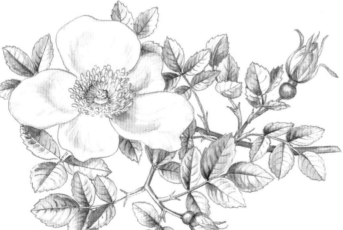

Wild flowers

Plants growing wild tend to be unrestrained in growth and may have an untidy look. This may be considered part of their character, but it is important to select a piece for drawing suitable for the size of the illustration. Take care not to pick any protected species or any plants in nature reserves.

Choosing plant material

Try to find healthy material without damage or disease. Illustrations of florists' and garden flowers tend to display a perfect 'show' specimen without defects, as an example of high quality plant material and good cultivation. Identify your plant and check that it is all right to collect some to draw. It is better not to pick material from a small plant or take the only one of something.

Collecting and keeping it fresh

Remember to take with you all the necessary things to keep the plant material fresh and bring it back to where you will draw it. A plastic bucket with two or three inches of water in, a pair of secateurs and polythene bags are useful, also water-absorbing floral foam to keep it upright. Cut the ends of the stems underwater as soon as possible to prevent wilting. Write down anything interesting about the plant and its origin in a notebook and attach a label with its name, especially if you are collecting from more than one plant.

Items for collecting live plant material
Back row from left: bucket for large specimens; trug with plastic box containing a little water. Middle row: floral foam; water bottle cut so that the top is a lid, containing floral foam and water; food container and lid with floral foam and a little water; plant labels; pencil. Bottom row: notebook; secateurs; florists' scissors.

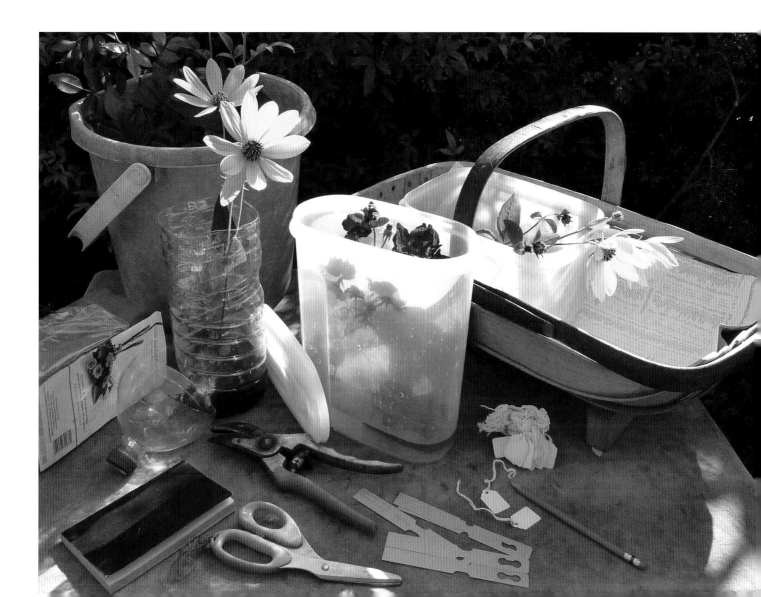

Choosing the technique

With a variety of possible painting and drawing techniques to choose from, a decision has to be made about which would be appropriate for the subject. This is not just a matter of imagining how the finished illustration will look. Other factors affecting this choice include whether the plant subject is alive or a dead specimen and how much time there is for the illustration. Nearly all work begins as a pencil drawing which can be completed quite quickly, but this can be developed further using a range of full-colour or monochrome techniques. If a fair copy is to be made, the first drawing may be treated more freely, with shading and colour notes quickly added. If the subject is a dead specimen, a monochrome technique such as pen and ink is appropriate because the natural colour is missing and the botanical features can be adequately shown in line drawing. With a living plant, the choice is wider. A commissioned illustration may require a certain medium such as watercolour, but otherwise the artist has the full range of techniques to choose from.

Various techniques are illustrated from top right downwards:

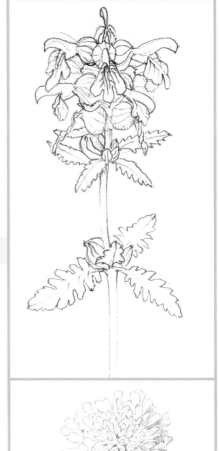

Pencil drawing

This is the easiest way to begin an illustration, with sketches first, and then an accurate drawing. It can provide the foundation for any other technique or it can be developed as a medium in its own right.

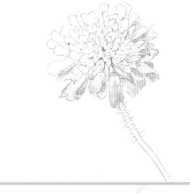

Pencil with some colour

Working drawings can be partly painted to record colour and then redrawn for a finished illustration, or neatened and kept as a quick record of something interesting in a sketchbook.

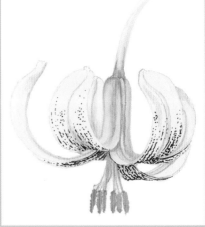

Watercolour

This is the most versatile technique for lifelike illustrations in full colour and the transparent colour reproduces well in print.

Monochrome painting

Washes of a single colour added to a drawing, using either ink or watercolour, provide a quick way of shading to give a three-dimensional effect.

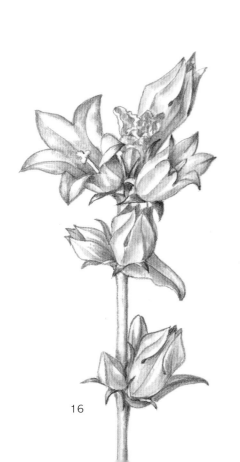

Gouache

Gouache colours are compatible with watercolour, but their opacity means they can be used on a dark background of tinted paper. This is useful where a background colour is wanted. Successive layers of paint can be used to build up light areas using washes, as with watercolour.

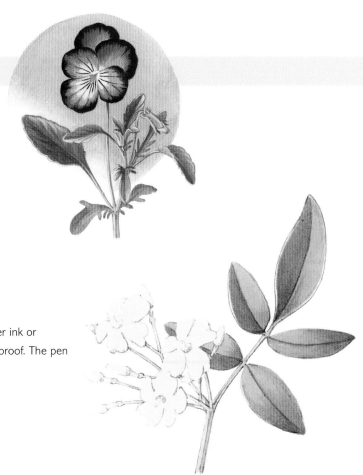

Line and wash

Colour can be used over lines drawn with a pen, using a wash of either ink or watercolour. If using colour over black ink, make sure the ink is waterproof. The pen lines give a precise quality to the work.

Pen and ink

Most scientific botanical illustrations are made in black ink using a technical drawing pen or rapidograph (a technical pen that controls the flow of ink). This gives a line of even thickness and round dots for stippled shading, whereas a dip pen will give lines of varying thickness according to the pressure of the hand, making it suitable for a more expressive style of drawing.

Magnified drawings

Some features are too small to see properly at natural size, but one can plan to include a magnified detail of a flower somewhere when designing the illustration.

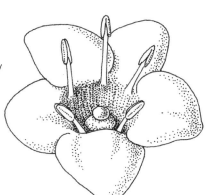

Reduced scale drawings

Many plants are too big to illustrate life size. In this case, a particular part can be drawn life size and a reduced scale drawing can be included to show the whole plant.

Your work space

The ideal situation is to have a permanent work space where your work and drawing and painting equipment can be left out ready for use. Starting from the basic minimum, what are the most important items which will help you do your best work?
I recommend the following:

A firm table, near to a window with daylight from the left (for right-handers) or from the right (for left-handers).

- An anglepoise table lamp for dull days and dark evenings.

- A table easel.

- If you do not have a table easel, a drawing board which can be raised at an angle with a baton (or a brick paving stone covered in bubble wrap).

- A chair or stool at the right height for the table, so that your shoulders are comfortable and your drawing arm is above the table surface. This is even more important for line drawing with a pen than it is for painting.

- Your tools for drawing and painting should be near your drawing hand, either on the right or left side of your work.

- A portfolio or carrying case in which to keep sheets of paper and work you have done.

- A box or cupboard for art equipment.

A table set up for botanical art

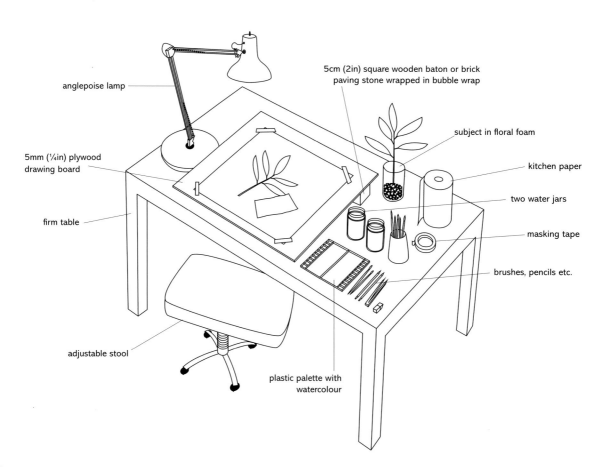

anglepoise lamp

5cm (2in) square wooden baton or brick paving stone wrapped in bubble wrap

subject in floral foam

kitchen paper

5mm (¼in) plywood drawing board

two water jars

firm table

masking tape

brushes, pencils etc.

adjustable stool

plastic palette with watercolour

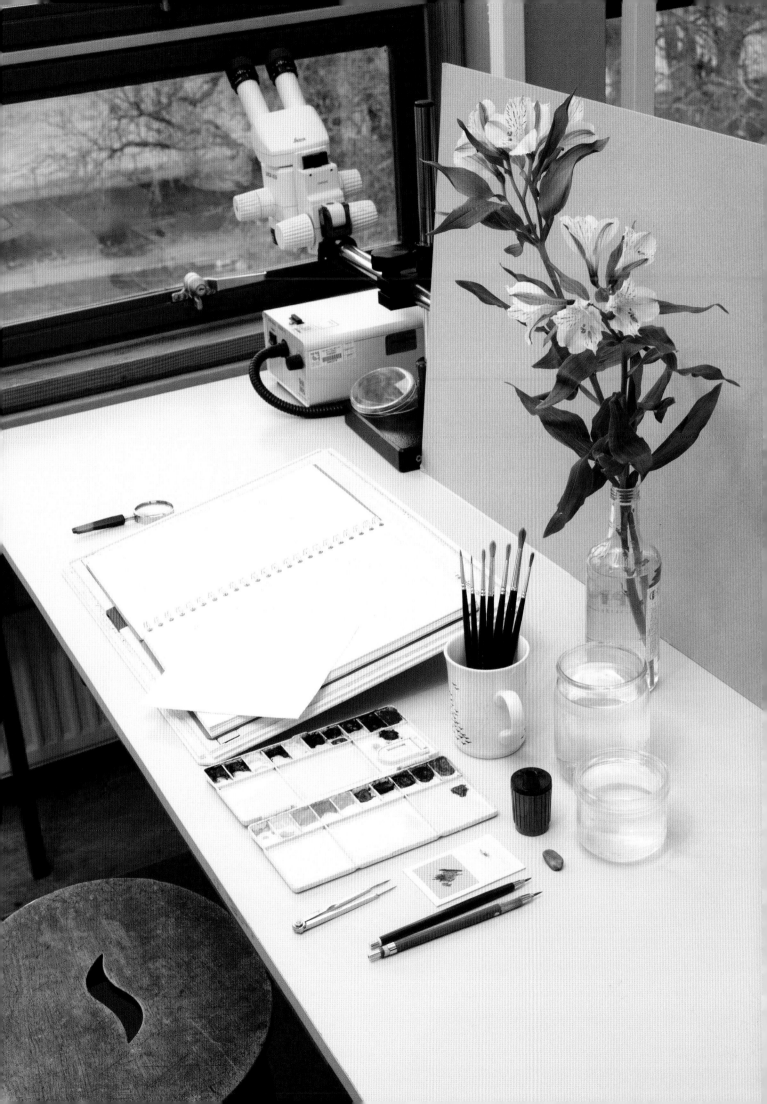

Drawing from life

The most enjoyable part of botanical illustration is drawing from life. There is the opportunity to look carefully at a plant and appreciate fully the colours and textures which can be found there. It is a demanding discipline because it requires continual reference to the subject of the drawing, checking sizes and proportions whenever necessary. Every plant drawn adds more experience to the next one.

Botanical illustrations for science are intended to depict plants as they are, without enhancement or interpretation. The more detailed information there is in the image, the better it serves as an illustration. If the plant is not shown at natural size, a bar scale can be included to show how big it is. This is often omitted if the size is stated in the text.

One of the challenges in drawing live plants is that they change. Flowers wilt and die and stems bend towards the light. If the drawing cannot be finished quickly, photographs are useful as reference for the colour. However, it is not a good idea to work entirely from photographs because the result will seldom look lifelike.

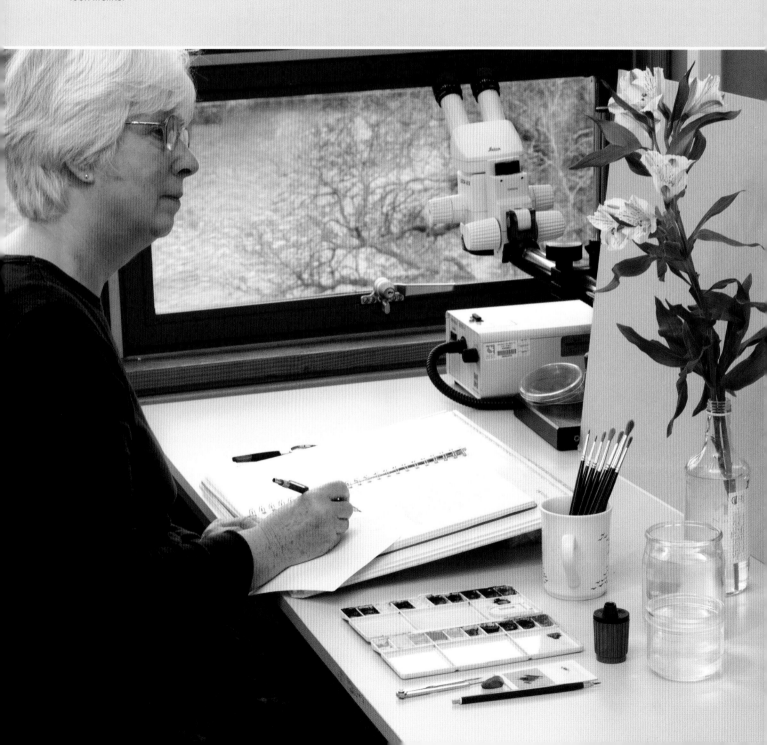

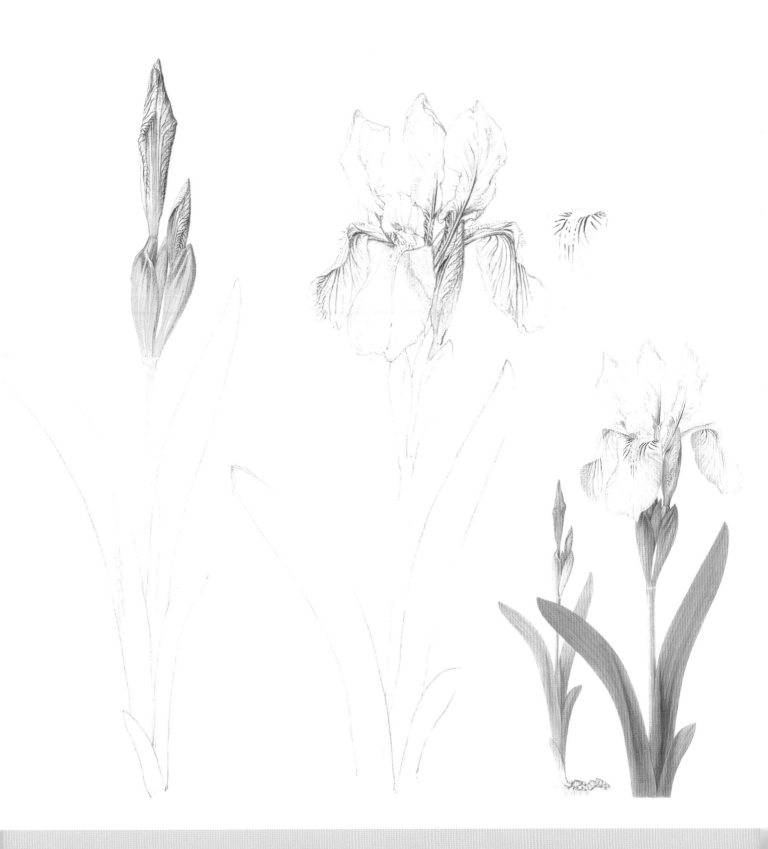

Iris bloudowii

This is difficult to flower in cultivation. The flower was drawn before it opened and then again when fully open. It faded later the same day. The published illustration was made using these working drawings of the flowers and the leaves were painted from life. It is shown on the far right: plate 577, *Curtis's Botanical Magazine* Vol. 24, (1) 2007, much reduced.

Composition

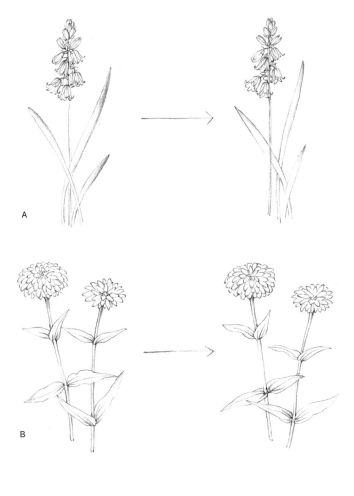

The composition of a botanical illustration should give an impression of how the plant looks when it is growing. If you are drawing a plant growing in a pot, this should not be a problem, but with a cut piece, care must be taken to orientate it correctly, especially if you have not seen it growing. Leaves should be orientated with the upper surface towards the light, and if the shoots hang downwards, it may be necessary to suspend the specimen on a stand in order to position it naturally.

The shape of the plant should look comfortable within the area for the illustration. This will usually be some type of rectangle. If there are strong lines of stems, avoid pointing these at the corners of the rectangle. Also avoid a point touching a line, such as the tip of a leaf just touching a stem or leaf edge, or three lines crossing in one place. Usually it is possible to move some component of the design a little to one side so that the tension is broken. It is surprising how quickly the eye goes to uncomfortable places in a composition, searching to see how things are joined or where they originate.

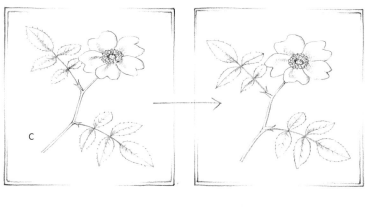

Show clearly how the flowers and leaves are joined to the stems and which belong to which stem. This applies mainly to plants which have complicated leaves or inflorescences. It makes sense to begin with a sketch of the structure so that if the subject wilts when it has been cut, you have a record of how it looked. The wilted parts can be positioned using the sketch as a guide.

Too much foreshortening in the composition should be avoided by arranging the viewpoint carefully. Show at least one leaf face on to the viewer so that the shape can be seen easily.

Configurations to avoid include more than two lines crossing at a place (A), a point resting on a line, such as the tip of a leaf on a stem (B), diagonals pointing at the corners of a rectangle or square (C) and lines too evenly parallel (D). The drawings on the right in each case show how to improve the composition. In example (B), for instance, the leaf tips that touched leaf edges have been moved, either not to reach the edges, or to extend beyond them.

Artists' licence

Avoid using artists' licence, unless it is really necessary. It may be if the plant to be drawn is badly damaged and has to be reconstructed. However, the plant itself is always more authentic than any ideas about composition.

Do not be tempted to add anything unless you are replacing a dead leaf or flower. Even this is to be avoided, because the flowers in an inflorescence open in a certain order and it may be impossible to find that number of open flowers on one inflorescence.

Sometimes there are so many leaves or inflorescences that it is tempting to leave some of them out because otherwise the composition looks very confusing. One way round this problem is to use aerial perspective, where features at the back are drawn paler, as if hidden by mist in the air (hence 'aerial').

The only situation where one may have to use artists' licence is for stems which might need to be a little shorter or longer to fit into the space. As this is affected by the amount of light a plant had where it was growing, it can vary a lot. Even so, it is better to draw it as it is.

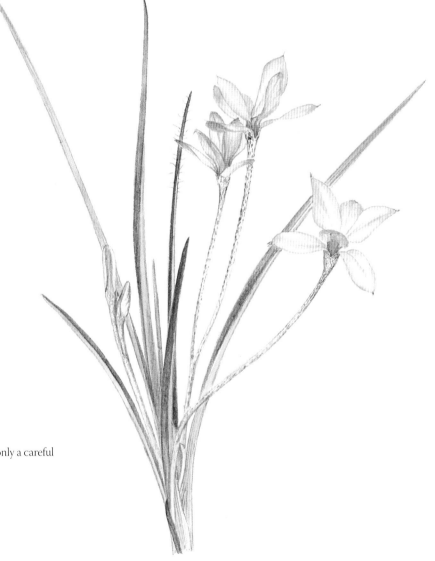

Rhodohypoxis baurii var. confecta
Working drawing. A plant which is naturally elegant needs only a careful choice of viewpoint for a good composition.

Criticism

It may be much easier for another person to offer helpful criticism of a painting than it is to use self-criticism on one's painting. However it is important to develop the ability to criticise one's own work. It is often not possible to start again but it will affect what you do next time.

Light and shade

The highlights and shadows on an object reveal its three-dimensional form. With only an outline, there is nothing to indicate what the solid form is like, but shining a light at the object reveals the form by the shape of the shadow areas.

When the object is a plant consisting of leaves and stems, the shadows and highlights reveal the form of the separate parts of the plant and also clarify the relationships of the parts of the plant in space: which parts are nearer to the viewer and which further away. The pattern of light and shade is therefore a useful tool which can be used when portraying a three-dimensional plant as a two-dimensional illustration.

These drawings of an orchid plant with pseudobulbs illustrate this point.

It is impossible to tell what the cross-section of the pseudobulb is like from the outline drawing (right). The drawings below with light from either the right or left side show that the pseudobulbs are round but flattened in cross-section by means of the shadows.

Three diagrams of *Leochilus johnstonii.*

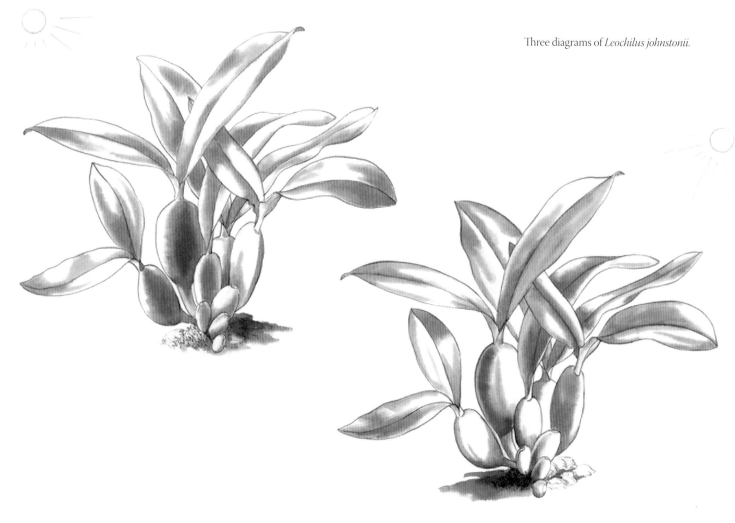

The light in your work space should shed plenty of light on the paper, but there is also the lighting of the plant material to think about. It may be possible to use one light source for both the drawing and the plant, but sometimes a separate light source may be needed which you can move about to arrange the best possible pattern of light and shade on the plant.

If the light shining on a plant results in shadows which are too dark so that no details can be seen, a piece of white card can be used to reflect light back into the shadows. This can be used for any rounded objects such as fruit to produce some interesting effects.

If you always have your light source in more or less the same position, you will get to know the likely shapes of shadows and highlights and this will enable you to design them to separate overlapping leaves and give depth to flowers, resulting in a lifelike illustration.

Highlights are the brightest areas of reflected light. Their position depends on the light source but their shape and intensity depend on the surface texture of the reflecting object. The leaf of *Rubus tricolor* on the right is shaded on one side as if it had a matt surface and on the other side it appears as glossy as it really is.

The five fruits below have different surface textures: in the top row the cherry is very glossy and has a small, intense highlight, the grapes and tomato also have smooth surfaces but are less glossy and the highlight spreads out further. The peach and kiwi fruit below have matt surfaces with no very bright highlight but instead a larger light area which grades softly into shadow.

Leaf of *Rubus tricolor* (above), and a cherry, grapes, tomato, kiwi fruit and peach (below).

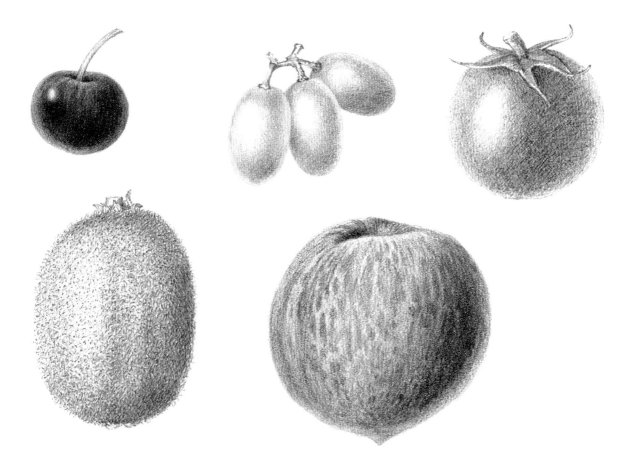

Sketching and drawing

Most botanical illustrations begin as pencil drawings. A pencil is comfortable and easy to use, and everyone is familiar with it. Marks made in pencil can easily be rubbed out and changed and the different grades of graphite from soft to hard can make a variety of lines and tones.

4H 2H HB B 2B 3B 5B

Grades of pencil useful for botanical drawing, from hard on the left to soft on the right.

Sketching

This is a loosely controlled way of finding the shape of what you are drawing, using pencil strokes, but without measurements and accurate details. A series of sketches from different angles, allowing comparison, is a good way to find the best angle from which to draw a subject. An HB grade pencil or softer (B or 2B) responds easily to the pressure and movement of the hand and is suitable for sketching.

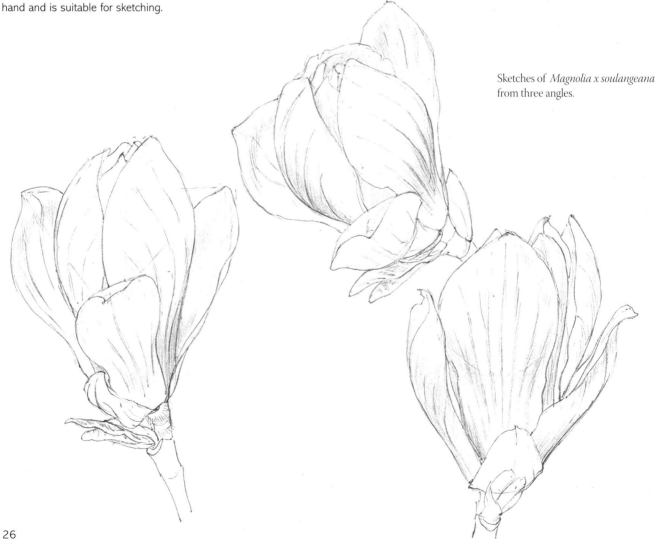

Sketches of *Magnolia x soulangeana* from three angles.

Drawing

A harder grade of pencil which will keep a sharp point is needed for accurate drawing; H or 2H are suitable. If the pencil is too hard, the sharp point can make a groove in the paper which cannot be rubbed out. A piece of fine emery paper on which to keep sharpening the point is necessary. Use a light pressure for the first lines in case they need to be rubbed out.

Clockwise from top right: sketches of *Incarvillea delavayi, Geranium sanguineum* and *Iris unguicularis.*

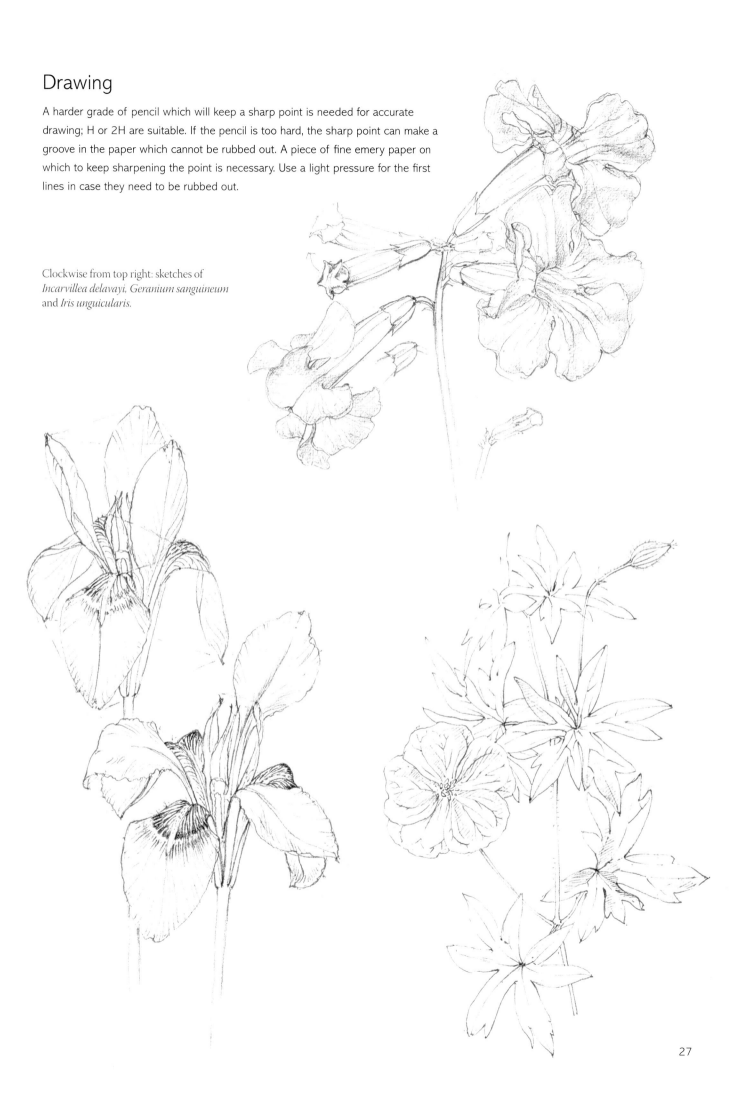

More developed sketches

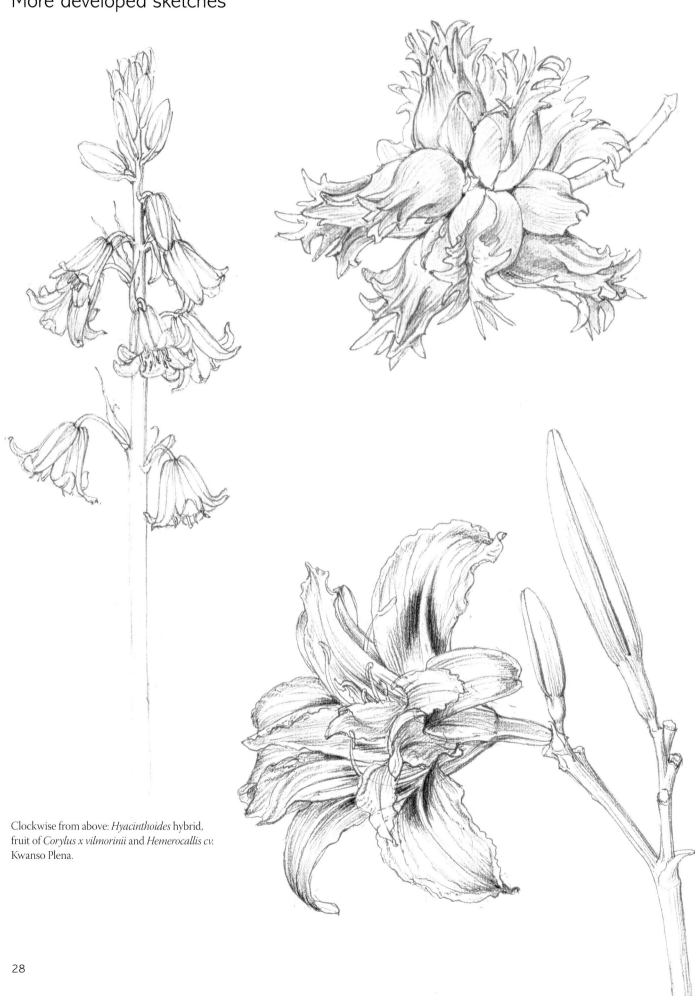

Clockwise from above: *Hyacinthoides* hybrid,
fruit of *Corylus x vilmorinii* and *Hemerocallis cv.*
Kwanso Plena.

Shading

Some shading can be added to an accurate drawing to give it three dimensions and complete it as a finished work in pencil. The most effective pencil drawings use the whole range from palest greys to very dark shadows and black but not too much of the middle tone. The modelling of light and shade is likely to be more important than colour effects when shading the drawing, otherwise a dull overall grey quality may result.

Pale shading is best done with hard pencils, 4H and harder, with rounded blunt points which will not scratch the paper. It is more difficult to control pale shading with a soft pencil and the result may be uneven or 'sooty' in quality. HB can be used for middle tones, soft (B and 2B) pencils for dark shadows and 3B for black. Keep the parts of the drawing you are not working on covered with layout paper and spray it with fixative to prevent smudging when it is finished.

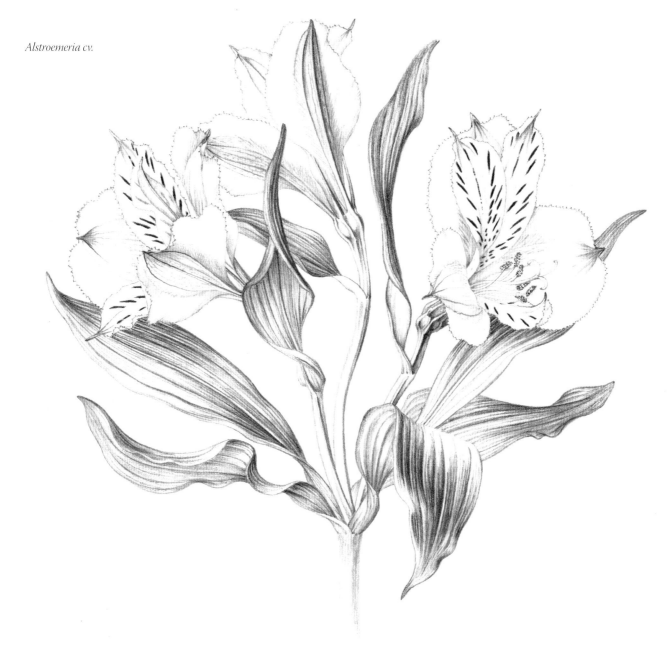

Alstroemeria cv.

Magnification

Many flowers are too small for the structure to be appreciated without some magnification. Features may be too small to be drawn clearly at natural size. A simple way to make an enlarged drawing at twice natural size is to use dividers to measure with and then mark the size twice on paper. Three times life size can be made in the same way.

Measure the width and length of the object to be drawn using dividers. For a natural size drawing, mark the dimensions once on the page, twice for x 2 and three times for x 3.

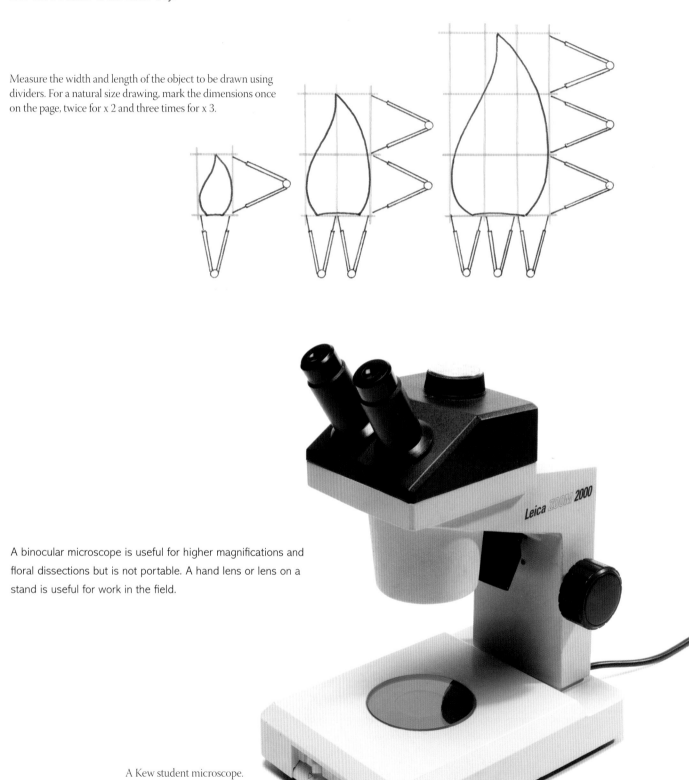

A binocular microscope is useful for higher magnifications and floral dissections but is not portable. A hand lens or lens on a stand is useful for work in the field.

A Kew student microscope.

Using a lens on a stand

A magnifying lens on a stand leaves both hands free to manipulate the subject being drawn. Mounted needles and a sharp blade can be used to take apart the tissue and reveal the structure of the plant material. The subject examined through the lens will only appear to the viewer about twice its natural size, but this is enough to reveal the structure of all but the smallest flowers. Keep the plant material moist in a dish of water while examining it.

An inflorescence of *Pedicularis verticillata* drawn x 1 (left) with front and side views of flowers drawn x 2 (centre) using a lens on a stand (right).

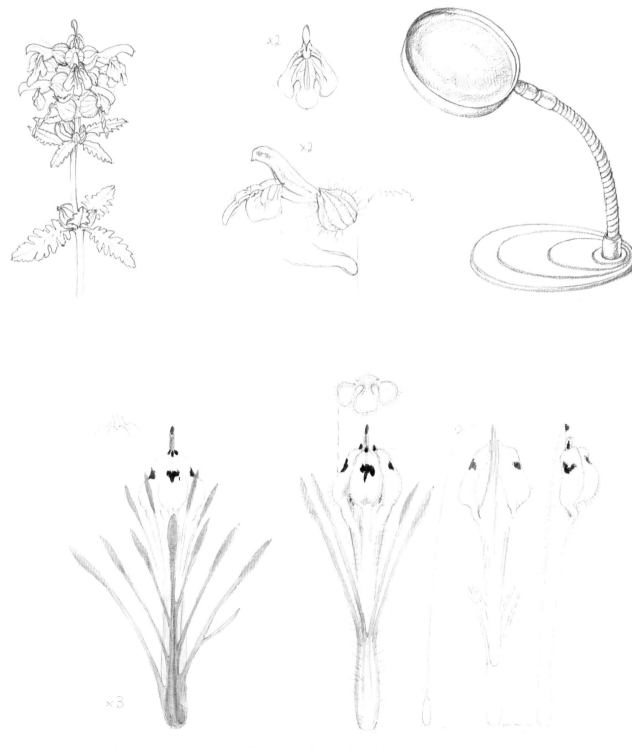

Floral dissections of *Castilleja exserta* drawn at x 3 magnification using the same lens as above.

Using dividers

Dividers are useful for checking sizes and proportions. For those who find drawing by eye difficult they are a godsend because all the drawing can be made accurate step by step by measuring with dividers.

When drawing a foreshortened leaf receding into the picture, the measurement you need is the size of the visible part rather than the size it actually is. In the diagram of Azalea leaves below, on stem (A), the apparent size of the leaf (CD) is measured with one point of the dividers on the part nearest the viewer and the other point vertically above it in line with the furthest point visible. If the leaves are turned through 90°, as shown on the left of the diagram on stem (B), the actual size (CB) of the leaf can now be seen as it is sideways on to the viewer. The foreshortened leaf further up the stem can be measured similarly.

Proportional dividers

Foreshortened Azalea leaves measured with simple dividers.

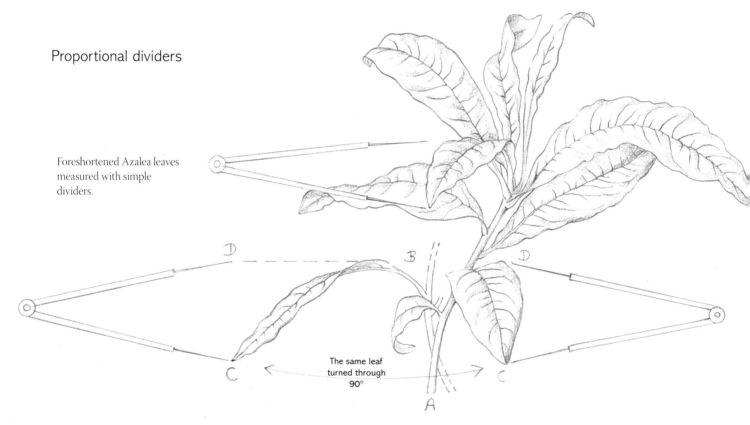

The same leaf turned through 90°

Proportional dividers (see diagram opposite) are used to enlarge or reduce the size of objects while drawing them. They are constructed so that the measurement at one end is larger than the other end, in whatever proportion is chosen by means of a central sliding scale. Numbered marks on the scale called 'lines' (rather than 'circles') indicate the proportion of the larger measurement to the smaller. When set at '2', the larger measurement will be twice that at the smaller end. This setting can be used to draw something either half or twice natural size. If the object is measured with the larger end, the other end will give half that size to set down on paper. Conversely, if the measurement is taken with the smaller end, the other end will give twice that size to set down on paper. Other commonly used ratios are '3' for 1:3 and '2/3' for 2:3. For the drawing of *Platanus orientalis* (opposite, top) all measurements were made at the setting '2', resulting in a drawing half natural size. It is a big saving in time to be able to make the drawing to scale in one step.

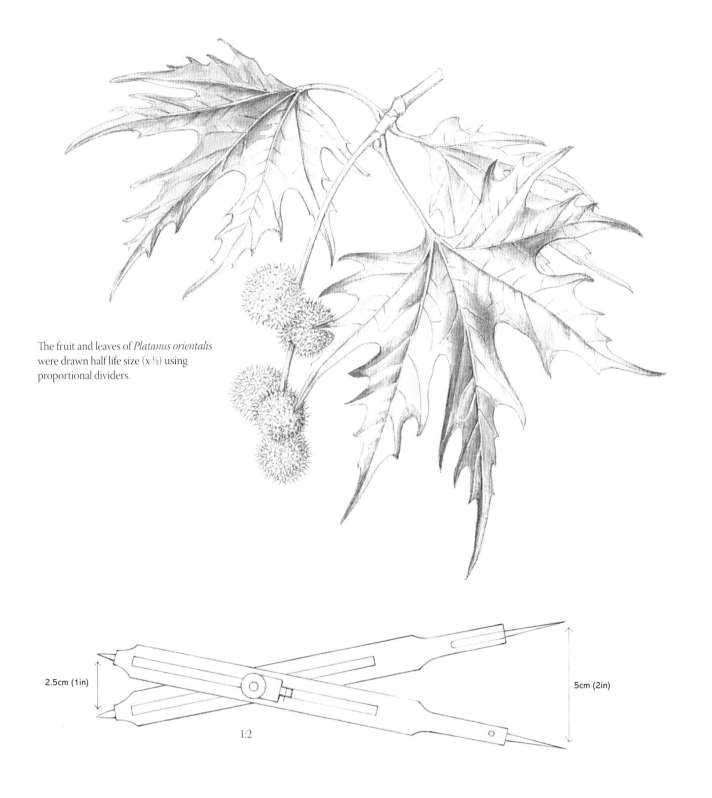

The fruit and leaves of *Platanus orientalis* were drawn half life size (x ½) using proportional dividers.

2.5cm (1in)

5cm (2in)

1:2

Proportional dividers set at 1:2 and at 2:3

Proportional dividers can be used to make drawings up to six times life size and they can also be used for reduction, to make drawings down to $\frac{1}{6}$ natural size. The proportion is adjusted by means of a movable screw along a calibrated slot.

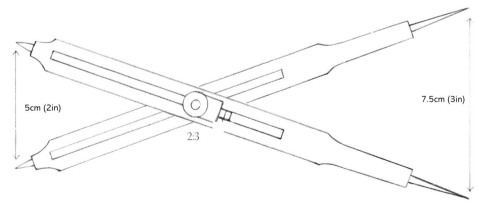

5cm (2in)

7.5cm (3in)

2:3

Transferring the drawing

Instead of drawing straight onto watercolour paper, you can make a design on cartridge paper and transfer it using a tracing. This saves the surface of the watercolour paper from roughness caused by rubbing out and redrawing. Use a 2H pencil to trace the lines, making them dark enough to be clearly visible. Turn the tracing over and scribble over the back with a soft pencil (2B) and then wipe off most of the graphite with kitchen paper. Turn the tracing back over so the right side is uppermost and position it on the watercolour paper with removable tape. Draw over the lines with a hard (4H) pencil to press the lines onto the paper. This gives a rather basic image which will need some neatening and cleaning up before painting. Check that the whole image is transferred before removing the tracing. Brush with a feather and dab with an eraser to remove any excess graphite.

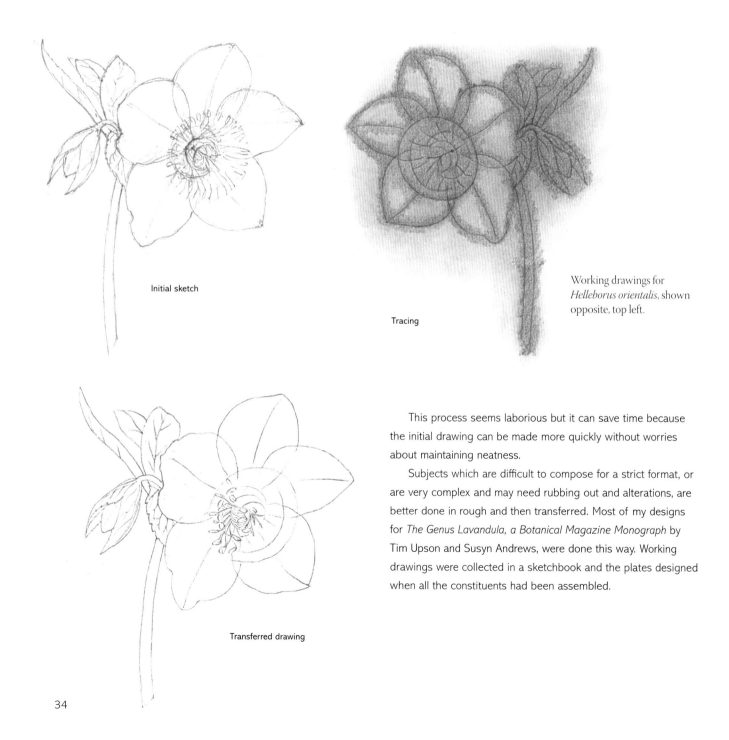

Initial sketch

Tracing

Working drawings for *Helleborus orientalis*, shown opposite, top left.

Transferred drawing

This process seems laborious but it can save time because the initial drawing can be made more quickly without worries about maintaining neatness.

Subjects which are difficult to compose for a strict format, or are very complex and may need rubbing out and alterations, are better done in rough and then transferred. Most of my designs for *The Genus Lavandula, a Botanical Magazine Monograph* by Tim Upson and Susyn Andrews, were done this way. Working drawings were collected in a sketchbook and the plates designed when all the constituents had been assembled.

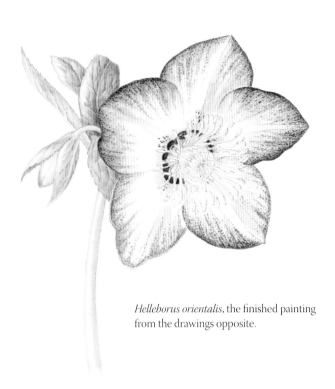

Helleborus orientalis, the finished painting from the drawings opposite.

Working drawings of *Lavandula multifida* (right) for Plate 14 in *The Genus Lavandula* and (below) the published version much reduced.

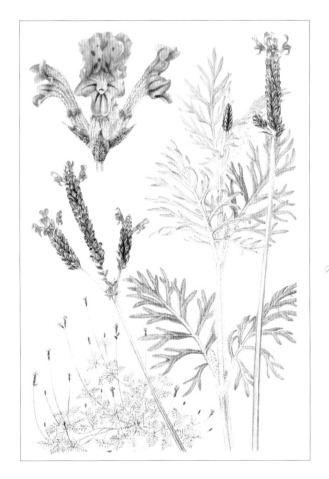

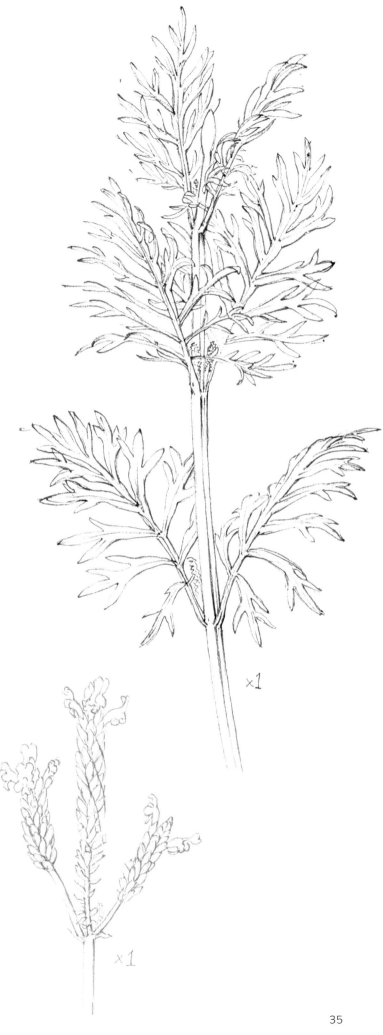

×1

×1

Using a shading guide

This is a way of recording highlights and shadows on a drawing without changing the fair copy. As it is quick to do, it is useful whenever time is short, either because the subject is something that will change quickly, wilt and die, or because one has to stop work and do something else before the work can be finished.

The drawing and shading guide for the painting of the Camellia opposite. I made a shading guide for the leaves only, as the flower was completed straight away.

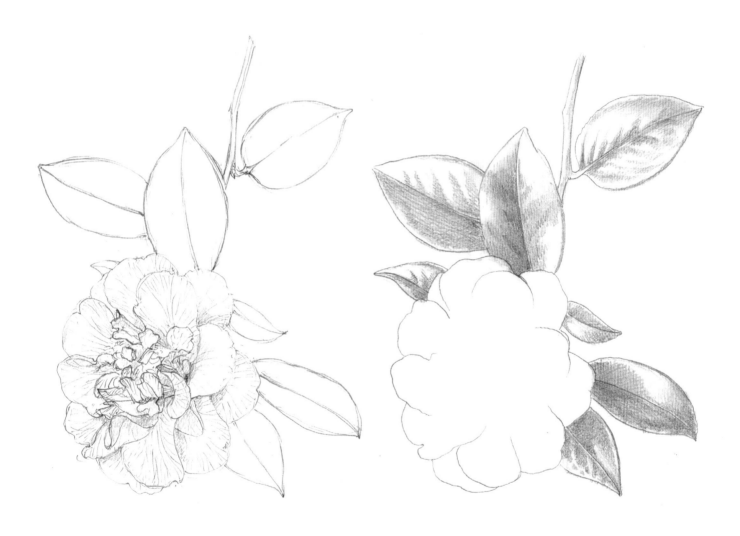

After making an accurate drawing, cover it with a tracing paper overlay on which to make the shading guide. Record the pattern of light and dark using pencil shading, then trace sufficient outlines for the shading guide to make sense when removed from the drawing underneath and backed with a plain sheet of paper. Some parts of the finished painting (opposite) are left unfinished to show the intermediate stages of painting the leaves.

Camellia x williamsii **Elegant Beauty**

The top right-hand leaf is left unfinished to show an intermediate stage.

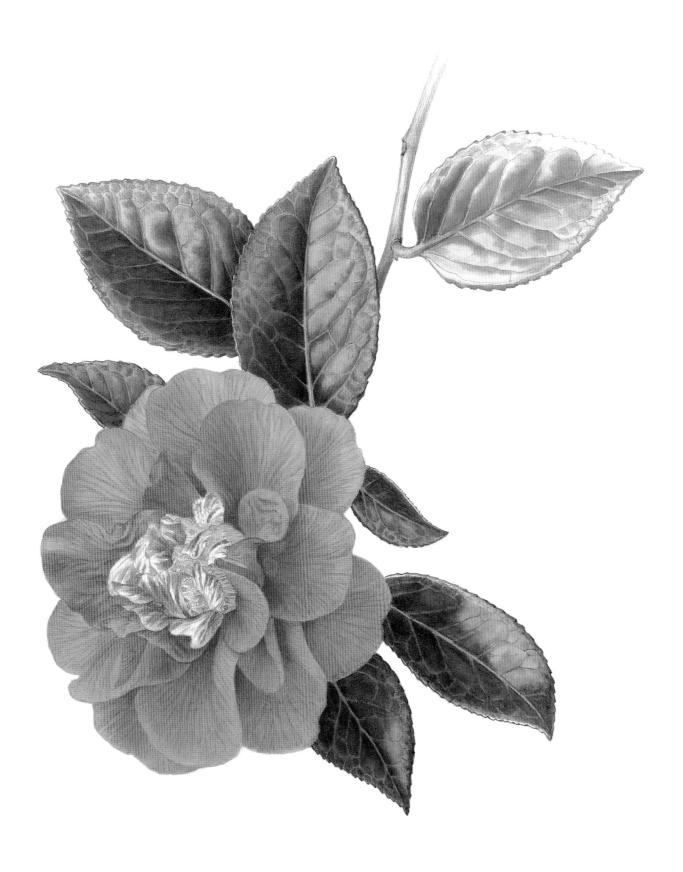

Watercolour

Transparent watercolour is the favourite medium for botanical illustrations as it reproduces well in print. A detailed and finely finished result can be achieved with good quality sable brushes on white smooth-surfaced paper. The paint can be applied with brush strokes or as an area of wash. Layers of dilute colour can be used to reach the required strength, allowing each layer to dry before the next is applied. It is easier to control the result when working this way rather than applying one wash of more concentrated colour. To prevent hard edges forming, a second brush holding only water can be used to moisten the paper near the edge. Alternatively, the whole area can be moistened before the paint is applied so that the colour runs out into the damp paper. Practice will develop a sense of how much water to use. Uneven areas can be smoothed out using a small brush filled with dilute colour.

Pencil lines can be replaced with paint to avoid dark edges, especially when painting pale flowers. A dip pen can be filled with dilute colour using a brush, and fine lines can be drawn next to the pencil lines, which can then be rubbed out. The dip pen with colour is also useful for small details and for dots and markings on flower petals, where a brush tends to make a triangular mark rather than a round dot.

Laying washes

Make sure the area you want to cover has a recognisable edge, because any hesitation will result in a 'tide-mark'. With a brush fully charged with colour, lay paint along one edge of the area and then move to and fro across it to cover it with paint. You must use a big enough brush to cover the area in one go.

To create a graded wash, have a brush full of water to hand as well as the brush full of colour. Use the water brush to soften the edge of the coloured area. It may prove easier to moisten the whole area with water before applying the colour so that gradation occurs within the wet surface.

An exercise with grapes

Draw the outline. Moisten the whole area of one grape. Apply paint around the highlight area. Try to achieve a soft edge around the highlight.

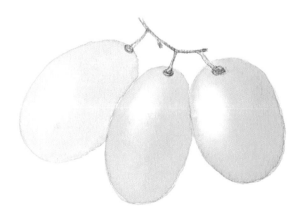

Bunch of three grapes
There is one wash of colour on the left-hand grape, two washes on the central grape and three washes on the right-hand grape. Each was allowed to dry before the next was applied.

Four ways of applying watercolour

Brush strokes

Use a small to medium size brush with a good point.

A flat wash

Use a brush large enough to cover the whole area with paint. Allow to dry before applying more colour.

A graded wash

Particularly useful for highlight areas. Fill one brush with colour and have another to hand filled with water, to moisten the paper surface and prevent a hard edge forming.

Fine brushwork

Small amounts of paint are applied with a fine brush. Miniature brushes are good for this technique

 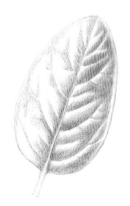

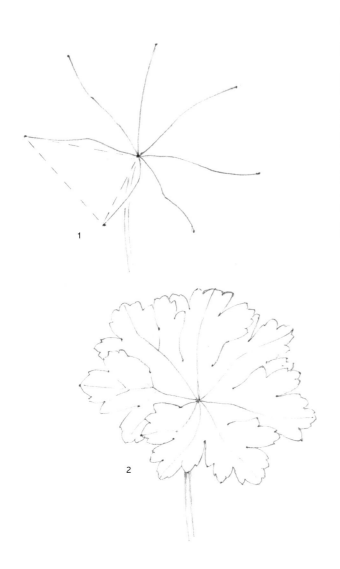

Stages in painting a leaf of *Geranium x magnificum*

1 The main veins in pencil, measured with dividers and drawn accurately.

2 The outline.

3 The venation.

4 The pencil lines are replaced with green watercolour using a dip pen.

5 Areas of light and shade are defined with pale washes of watercolour.

6 The finished leaf.

1

2

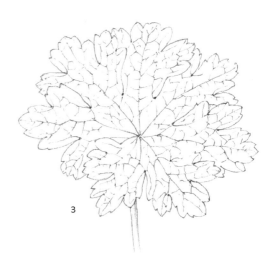

3

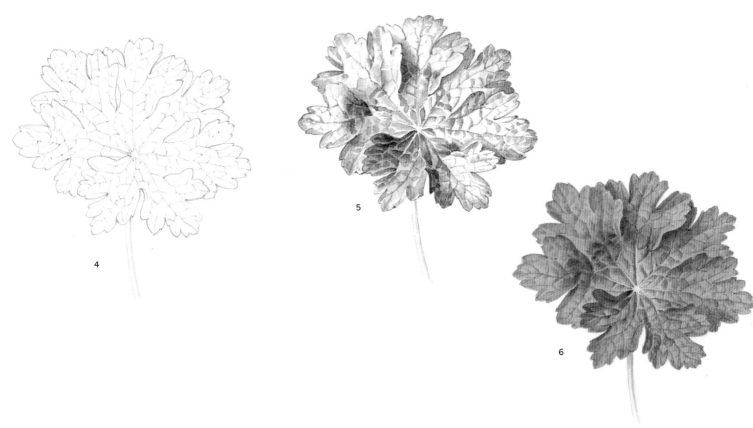

4

5

6

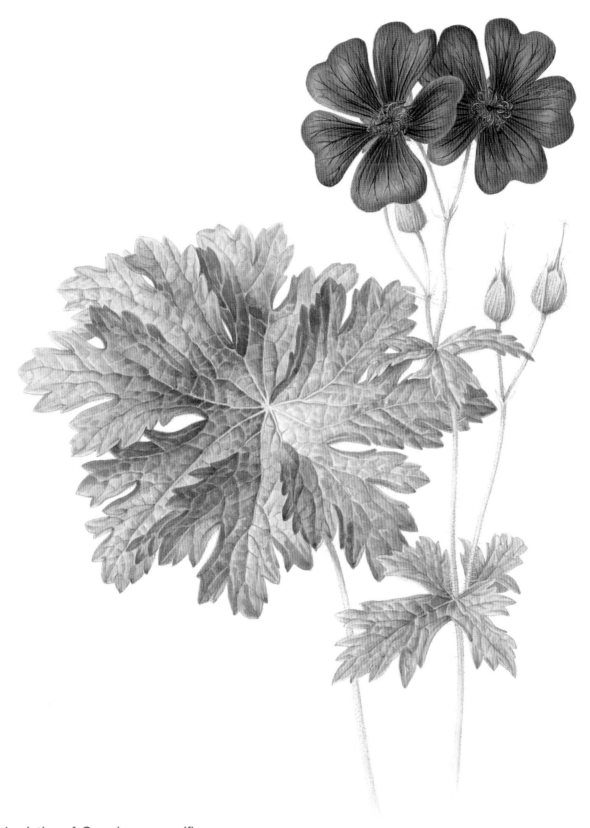

A finished painting of *Geranium x magnificum*

The colours used were indigo and cadmium lemon for the leaves and carbazole violet and permanent rose for the flowers, with neutral tint for the dark veins.

Gouache

Gouache is a type of water-soluble paint which is opaque rather than transparent. The range of colours available includes some which are not lightfast, so care must be taken, if paintings are to be framed and hung on display, that the best colours are chosen. The paint dries to a matt surface and has a thick, creamy consistency, but it can be diluted with water and used in the same way as transparent watercolour. The two types of paint are compatible and can be mixed together or used in layers of washes. The colour tends to dry a paler shade than it looks on the palette, so experiments are needed to find out what it will look like before putting it in the painting. My choice of gouache colours are shown on page 12.

Gouache can be used to great effect for many natural history subjects such as iridescent insects, butterflies' wings, the feathers of birds and the fur of animals. It is especially effective on a tinted background. In botanical illustration it is useful for the spines of cacti and any other small plant features which need to be pale against a darker colour. Not all colours are equally opaque. The manufacturers provide a key to opacity on colour charts and on the tubes. Even with opaque colours, several coats may be needed to cover an area perfectly.

Using gouache paints

A white ceramic tile with a flat surface makes a good palette. Squeeze out only the colours you need, because the paint dries quickly and becomes hard. If it does dry, the paint can be reconstituted by moistening and then rubbing it with a palette knife until it dissolves. The palette knife is also useful for mixing shades of colour, because a paintbrush is not stiff enough for the thick, creamy texture of the paint. It is better to use artificial fibre brushes such as those used with acrylic paints, with gouache paint.

The flower of *Clematis 'Voluceau'* (below) was painted using neutral tint and carbazole violet watercolour followed by quinacridone magenta, permanent alizarin crimson and permanent rose gouache with titanium white. The greenish grey paper was made with washes of Payne's gray mixed with hansa yellow light on smooth 300gsm (140lb) Fabriano watercolour paper.

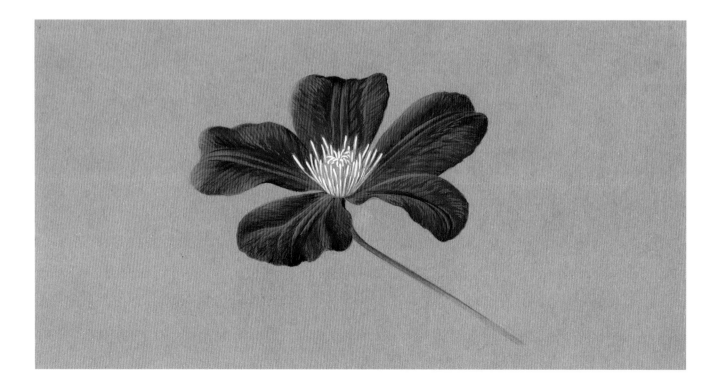

Tinted paper

Various shades of tinted paper are on sale but it is more interesting to make your own. The key to getting an even surface is to use a large brush which will hold enough paint. Even so, you will probably have to refill it to cover a whole piece of paper. Use either 'smooth (HP)' or 'Not' surface watercolour paper of 300gsm (140lb) weight or thicker, and use dilute colour, allowing it to dry between each application of wash. Have the paper fixed to a board and prop this at a slight tilt. Start each application at the top edge so that the paint runs downwards and move the brush to and fro across the paper. The paper for *Eranthis hyemalis* was tinted with neutral tint mixed with sepia watercolour. Various effects can be made by mingling the colours on the paper. It is worth experimenting with mingling or shading two or more colours together which harmonise with the colour of the main subject.

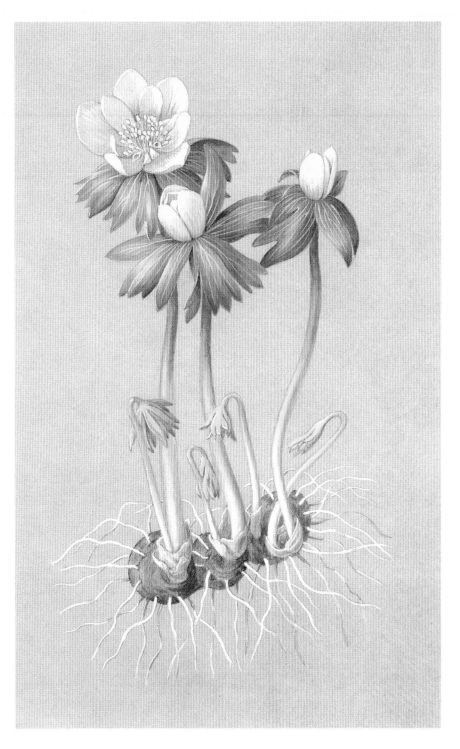

Eranthis hyemalis
(Winter aconites).

Stages in painting an ivy leaf

The first two stages were painted in Payne's gray and cadmium lemon watercolour. At the third stage, gouache colour was used to pick out the veins, add highlights and enrich the leaf colour. Mixtures of chromium oxide, cadmium lemon and permanent white were used with a little lamp black for the darkest areas.

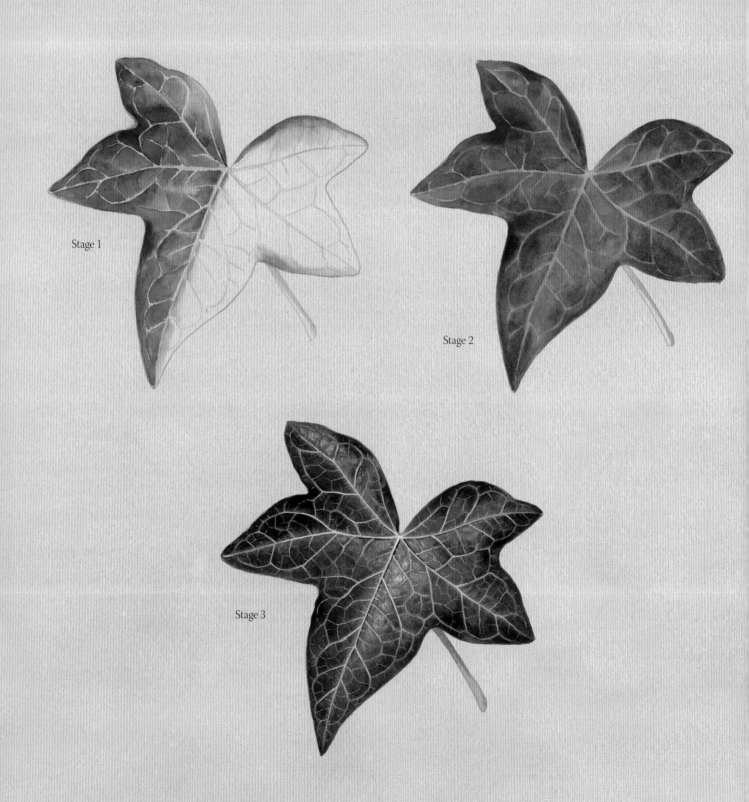

Stage 1

Stage 2

Stage 3

Bullace *(Prunus institia)*

This is a relative of the sloe with larger flowers. The subject was sketched in rough and then transferred to the tinted paper, which was made using neutral tint and sepia watercolour. This avoided rubbing out, which might damage the tint. The white flowers were painted in gouache over a detailed pencil drawing, which remained to give firm outlines to the flowers and buds.

Pen and ink

Line drawings in pen and ink are the preferred medium for most scientific botanical illustrations because they can be easily reproduced among text for publications. Line drawings are most suitable when working from preserved specimens, as the natural colour is lost. The most popular drawing tool is a technical drawing pen with a tubular nib, also known as a rapidograph, which makes lines of even thickness and round dots for stippled shading. Alternatively a dip pen and ink can be used, usually with black ink but also with watercolour or coloured ink such as sepia.

A

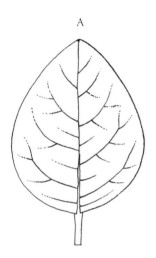

B

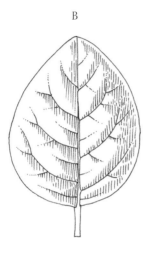

C

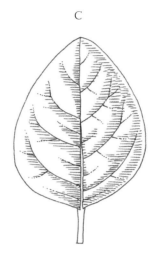

D

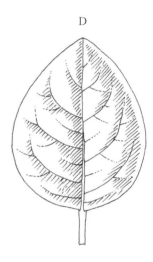

A: lines of varying thickness drawn with a dip pen.

B, C and D: lines drawn with a rapidograph.

B: shading parallel to the main vein.

C: shading at right angles to the main vein.

D: shading diagonally across the leaf.

E: lines and dots made with a 0.25 rapidograph.

F: cross-hatched lines made with a rapidograph.

E

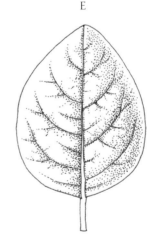

F

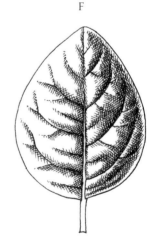

The four cylinders, which could be sections of stems, are examples of shading on curved surfaces. The lines were drawn first and the dots interspersed among them to increase the weight of the shading. Where there is a horizon rather than an edge to an object such as a round stem, the shading lines should give the impression that the surface continues beyond the horizon. This helps it to look three-dimensional.

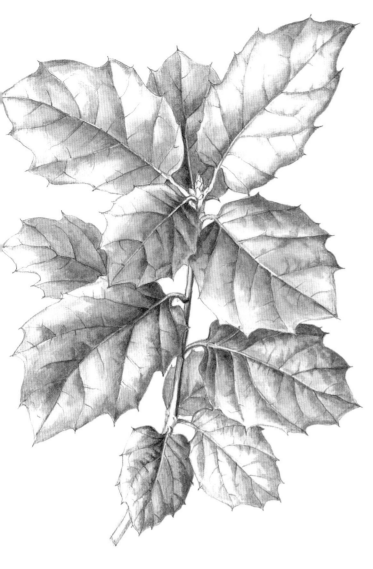

The pencil drawing of *Quercus agrifolia* (left) was shaded with monochrome black watercolour. This provided the information necessary for making a fair copy with rapidograph and black ink (below).

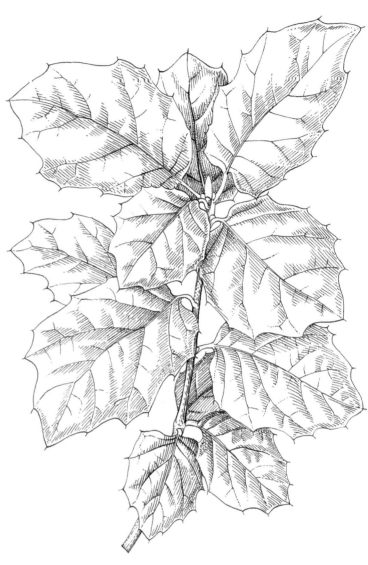

Stippled shading

For an even tonal effect, place the initial dots quite far apart and gradually fill the area in between. It is easier to control the weight of the shading by infilling rather than working over an area with a high density of dots. Use a rapidograph nib of 0.25 or larger so that the dots are big enough to show when reduced in size. Very fine dots may not show when printed and the shading takes a long time to do, but having said that, some people do produce very fine work with smaller nib sizes.

***Chimonanthus praecox* fruit**

Three stages in stipple shading.

Correcting mistakes

However careful you are, mistakes and accidents will sometimes occur. There are a number of ways to make corrections so that time is not wasted by having to start again. If the work is to be printed, corrections can be edited out when the work is photographed. The only reason to abandon work and start again is if there is something so fundamentally wrong that it is not worth spending further time on.

Preventing mistakes

Keep the work clean by protecting it with a piece of layout or cartridge paper over the part you are not working on. If you keep a piece of paper under your hand as well, it gives extra protection. Organise the work space so that paint and water are unlikely to splash or be spilled. Keep graphite pencil sharpenings away from where your hand rests and take care that the eraser does not get water on it. This can cause an unsightly mark which is hard to remove.

Mistakes in pencil drawings

Some rubbing out is inevitable, and in order to be able to rub out accurately, a good quality plastic eraser is needed. Erasers in the form of a pencil are useful, or wedges may be cut from an eraser to give corners for accurate rubbing out. It is sometimes possible to erase pencil lines under paint, provided the paint is dry.

Mistakes in paint

Mistakes in paint include a wrong colour, uneven texture and marks on the white paper around the image. If the colour is wrong, a wash of transparent colour can change it. Sometimes a quite surprising colour can be used in a dilute wash, such as violet blue to correct a green colour with too much yellow. Experiment to find the right solution. If the colour is too dark or too heavy, it may be possible to wash some of it out using a brush. If sable is too soft, try a stiffer artificial fibre one. Blot the damp surface with kitchen paper and let it dry completely before repairing details with fine brushwork. On the whole it is better to complete the painting using many layers of dilute colour, because this way, mistakes in the quality of the colour are less likely to occur.

A green with too much yellow, corrected with ultramarine blue.

A bright green altered with a wash of carbazole violet.

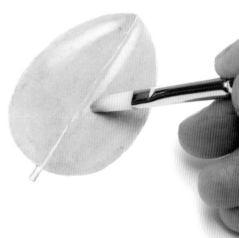

Removing colour with a stiff brush.

Scraping out

Unwanted marks can be removed by scraping away with a sharp knife and then smoothing the surface with a burnisher. It may be possible to work over the correction, depending on the type of paper.

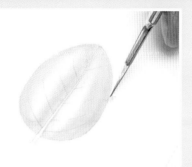

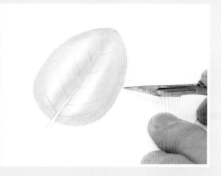

1 To repair an edge, cut along the correct line with a sharp blade.

2 Scrape away the unwanted area of paint and use an eraser to remove any last traces.

3 Restore the smooth surface using a burnisher or a smooth, rounded object.

Covering an indelible mistake with gouache

1 Remove as much of the mistake as possible.

2 Take a small synthetic brush. Mix a matching colour in gouache, allowing for change as it dries. Cover the mark, without extending beyond the edge.

3 Apply as many layers as necessary until the mark is hidden.

Correcting ink lines

1 Uneven lines can be straightened. Draw the correct line before removing the mistake.

2 Cut along the edge of the correct line with a sharp blade before removing the error.

3 Scrape away the mistake and burnish the surface (as in Scraping out, step 3).

Leaves

Plants rely on their leaves to capture energy from sunlight by means of photosynthesis, which enables them to grow. For this reason they are usually arranged to catch the maximum light on their surface. The flat area is supported by veins which act both as stiffening and as vessels for water, which keeps the leaf tissue from wilting. When drawing leaves, the main veins and the outline shape are the first features to put down on paper. Details of the margin such as serrations often relate to the ends of veins and can be added afterwards. Usually, veins taper towards the edge of the leaf, and a drawing should try to show the relative thicknesses of them, from the thick main vein down to the smallest which can be seen. Sometimes the smallest veins show only as a surface texture where light shines across the leaf surface. In this case it is the direction in which they join other veins which helps to characterise a leaf. Understanding of venation patterns may be helped by making leaf rubbings (see Advice for Beginners, page 123).

The following pages illustrate various types of leaf and how they can be painted. The visual qualities by which leaves are recognised can depend on such features as colour, hairs, a shiny surface, the pattern of veins and the arrangement of leaves on the stem.

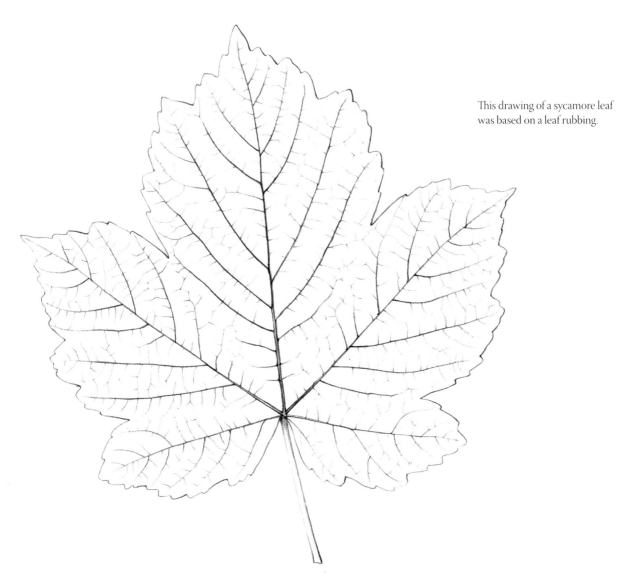

This drawing of a sycamore leaf was based on a leaf rubbing.

Leaf colour

I prefer to mix greens using blues, greys and yellows rather than using ready-made greens. A range of different greens which includes bluer to yellower shades, gives a more interesting result than just the light and dark of one type of green. If the colour is built up in layers of different greens, there is more control over the colour match to the live subject. I prefer to begin with a pale wash of a colour slightly more blue than the end result is to be. Increasing the yellow later in the process leaves the lightest areas and highlights somewhat bluish, as if they were reflecting light from the sky.

Colour combinations for painting leaves

Blue, grey and brown	Yellow
Winsor blue (green shade)	Cadmium lemon
Indanthrene blue	Hansa yellow light
Indigo	Aureolin
Payne's gray	Cadmium yellow
Neutral tint	
Sepia	

Mixtures of all these colours give a useful variety of greens, from the brightest colour of young leaves to the almost black dark green of some types of holly. The addition of a more orange yellow gives olive green and a mixture of neutral tint with cadmium lemon gives a surprising pale olive green, as does sepia and cadmium lemon. There are many more ways of making green and people have their own favourite colours, but the illustrations in this book were made using mainly indigo, Payne's gray, cadmium lemon and hansa yellow light, sometimes with touches of the other colours mentioned above.

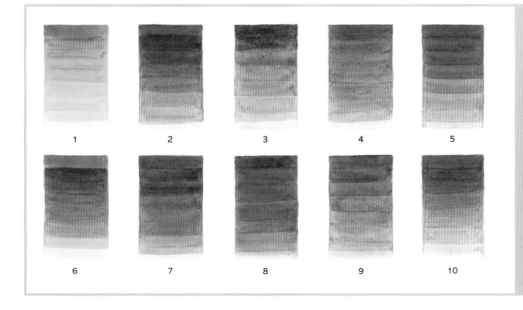

1 Winsor blue (green shade) + cadmium lemon
2 Indigo + cadmium lemon
3 Indigo + aureolin
4 Payne's gray + hansa yellow light
5 Neutral tint + cadmium lemon
6 Winsor blue (green shade) + cadmium yellow
7 Indigo + cadmium yellow
8 Payne's gray + cadmium lemon
9 Paynes gray + aureolin
10 Sepia + cadmium lemon

Dark green, shiny leaves

This *Ilex* cultivar without spines was chosen as an example of very dark green leaves. Matching a very dark green with watercolour is a challenge but it is better to avoid using black in the colour mixture. Neutral tint and Payne's gray will give pleasant dark green colours when mixed with a little cadmium lemon or hansa yellow light. These yellows are preferable to cadmium yellow for a dark colour mixture because they are more transparent. For shiny leaves such as these, apply successive washes of dilute colour to achieve soft gradations around the highlights. The colours used for this *Ilex aquifolium* (Holly) cultivar were Payne's gray and cadmium lemon with a little neutral tint in the darkest areas. The two stages in the washes used are illustrated below.

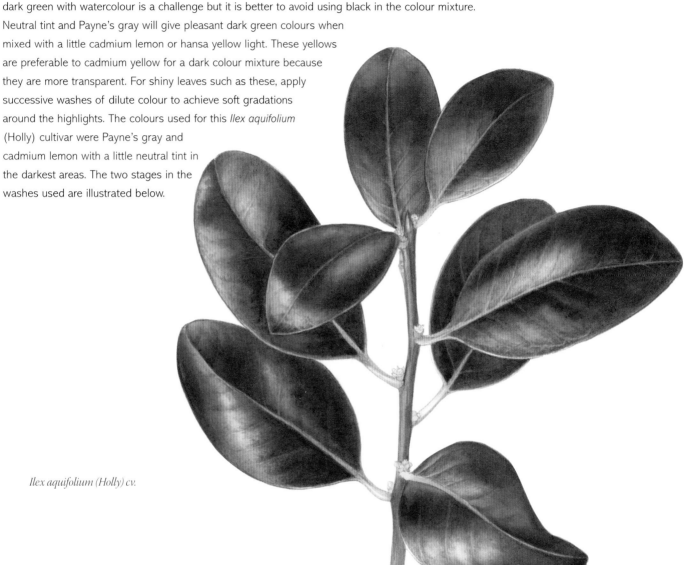

Ilex aquifolium (Holly) cv.

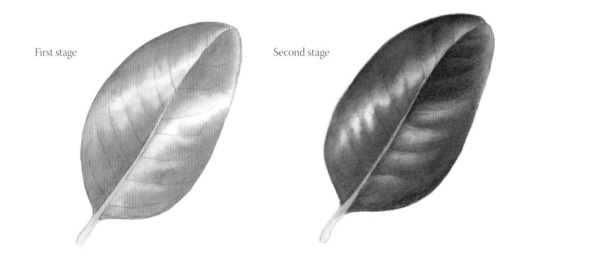

First stage

Second stage

52

A variegated leaf - cyclamen

When painting variegated leaves, put enough veins in at the drawing stage
to position the colour zones around them. The first stage of painting is to
indicate the pattern using a wash of very pale colour. After this, build up
the colour in layers to establish the necessary hues and contrast. This can
be time-consuming, but working slowly allows adjustments to the
balance of light and shade. For the *Cyclamen hederifolium* leaves
shown here, I used a variety of greens made from Payne's gray,
indigo and cadmium lemon.

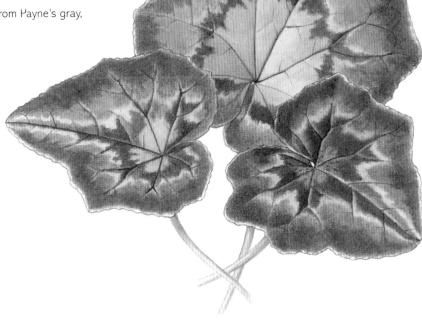

Cyclamen hederifolium leaves.

Intermediate stages in painting a
Cyclamen hederifolium leaf.

Stage 1

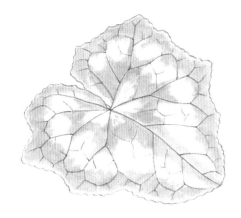

Stage 2

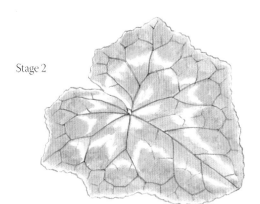

Stage 3

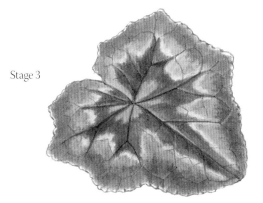

Leaves with reddish colouration

Reddish colouration often occurs on the leaves and stems of plants, and horticultural selections can be found showing all shades of reddish colour down to very dark purple. There is often a certain amount of bluish grey in the highlight areas of reddish leaves. The *Heuchera* leaf (bottom) was painted using a pale grey-green made with Payne's gray plus a little cadmium lemon, and mixtures using perylene maroon for the brownish red. For the *Prunus* (top), neutral tint was used, with perylene maroon and some permanent alizarin crimson to enrich the colour in places.

Prunus cv.

Heuchera cv.

Acer davidii **Plate 770 Vol. 30 (3) 2013**

The young leaves of *Acer davidii* are glossy and reddish when first emerging but soon turn green and lose their shine. In autumn they turn yellow before falling.

Leaf surface textures

Hairy leaves

Fine hairs on leaves can either be applied with white gouache onto a green basic colour or the effect of hairs can be simulated with tiny brush strokes of rather dry green paint, leaving the white of the paper to give the texture. The hairs on the two types of leaf below show different textures of fine brushwork; the hairs of *Stachys lanata* are fairly long and lie in a regular direction, whereas the hairs on the *Senecio cineraria* leaf are fuzzy. The colours used were Payne's gray, hansa yellow light and neutral tint. Most of the texture was built up with small strokes of a 00 brush, with some very pale washes of neutral tint in the shadow areas.

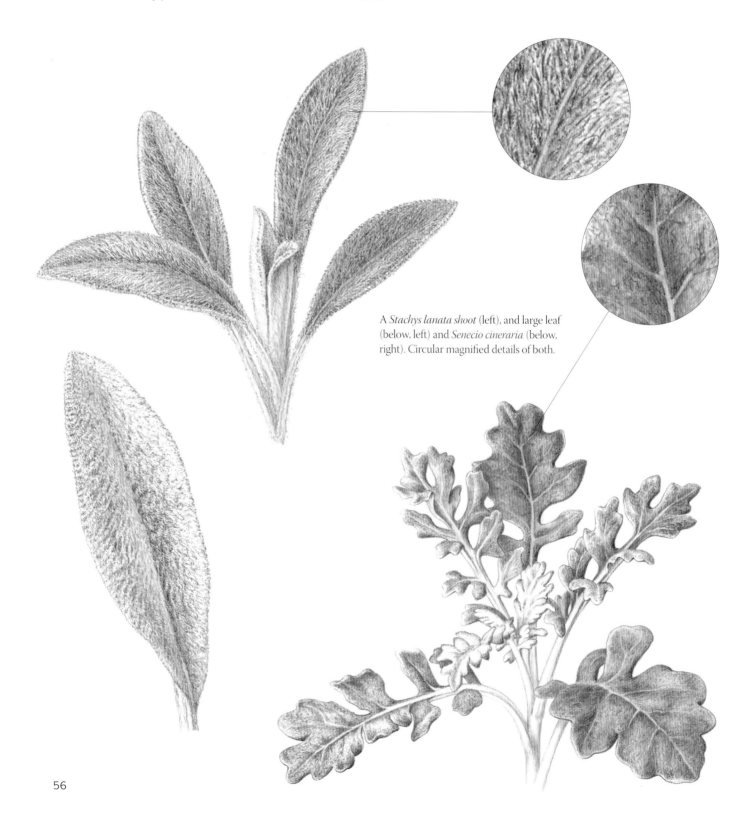

A *Stachys lanata* shoot (left), and large leaf (below, left) and *Senecio cineraria* (below, right). Circular magnified details of both.

Shiny and hairy leaves

These ilustrations from *Curtis's Botanical Magazine* show more leaf textures.

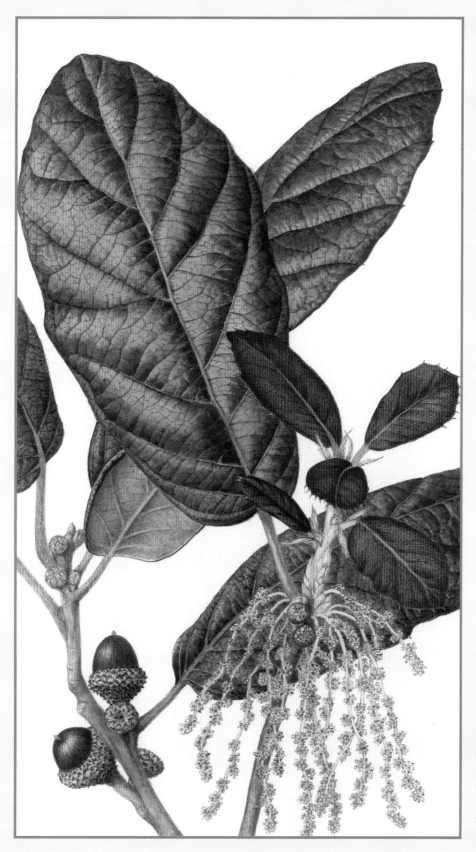

Quercus crassifolia Plate
735 Vol. 29 (2) 2012

The young leaves of *Quercus crassifolia* from Mexico are covered in crimson hairs at first, later becoming a smooth, almost shiny dark green. The leaf undersides remain covered in tawny felt hairs.

Leaf venation

The venation pattern is one of the main features which give a leaf a distinctive character, useful for identification. Colour and surface texture are also important and may affect how much of the venation can be seen. When making an illustration, one should try to show the venation realistically, bearing in mind that if every single vein is included, the effect may be too heavy. Often the smallest veins can be lightly indicated as a surface texture, revealed by light shining across the leaf surface. The smallest veins of the leaf of *Plantago major*, see below, are not really visible, but they are drawn in one area to show their pattern. Otherwise a slight puckering along the larger veins indicates their presence.

The simplest venation is where veins run parallel along the leaf and converge at the apex. Well-known examples are Irises and many bulbous plants. There may also be tiny veins which connect across the parallel veins, but these are not always as visible as they are in the young *Clivia* leaf below.

More complex patterns have one or more main veins as midribs supporting the leaf surface, with secondary veins branching away from them. A complicated pattern of tiny veins in the spaces between the secondary veins may be visible, but sometimes only on the underside when the leaf is turned over.

The relative thickness of veins is important: the way they separate and whether they rejoin at the outer edge of the leaf. If the leaf has a serrated margin, the pattern of the veins may relate to the serrations along the edge, as in the bramble (*Rubus fruticosus*) leaflet below.

The question often arises whether veins should be drawn with a double line, especially if they appear paler than the surrounding leaf surface. There is no general rule about this because of the immense variety of types of leaf, but to avoid over-emphasising the veins, double lines can be used only where the larger veins are highly visible, and limited to about two-thirds of the distance along the vein or less, tapering them away as a single line towards the edge. It very much depends on how noticeable they are.

Top row from left to right: *Iris germanica, Clivia miniata, Arum maculatum, Plantago major, Rubus fruticosus, Nerium oleander.* Bottom: *Alchemilla mollis.*

Leaf phyllotaxis – the arrangement of leaves on stems

The usual advice to draw what you see rather than try and fit it to a theoretical structure applies to the positions of leaves on a plant. In nature, leaves are very sensitive to light and will orientate themselves to catch the maximum amount. This may disguise the pattern of phyllotaxis.

Leaves are attached to stems at nodes, which are arranged either in a spiral along a stem, or in a whorl with one or more leaves around a stem at regular intervals. The spiral arrangement develops when leaf nodes separate as a stem elongates away from the growing point. The arrangement called 'opposite' results when there are only two leaves in each whorl and each whorl is at right angles to the one before.

When choosing a viewpoint at the start of a drawing, it is better to avoid a view where too many leaves are foreshortened or seen from the side so that the outline shape cannot be clearly seen. The two drawings (right) of *Hebe pinguifolia,* which has opposite leaves, show the same shoot from two slightly different angles. The view on the left shows the leaf shape better than the one on the right, which, although it shows the opposite arrangement well, has most leaves seen either from the side or foreshortened. The shoot of *Arbutus unedo* shown below has leaves arranged spirally around the stem. Drawing leaves around a stem can be difficult when even a slight movement of one's head changes their relative positions. If the leaves at the front are drawn first and each leaf is drawn the correct size and shape within itself, those behind can be placed in relation to them.

Top: *Hebe pinguifolia.*
Right: *Arbutus unedo.*

Flowers

The wide range of shapes, sizes and colours of flowers provides an endless variety of subjects for botanical illustrations. Studying the different floral structures and pollination mechanisms reveals the fact that the natural audience for flowers are pollinators, which are mainly insects. We humans look at flowers with extra faculties and we have preferences, likes and dislikes about them which are not related to whether or not seeds are produced to perpetuate the plant. Although the most visible characteristics are shape and colour, with or without scent, the patterns of spots and lines and patches of hairs arranged for visiting pollinators are also important to include in an illustration.

Impatiens morsei, three views.

Portraying a three-dimensional flower on flat paper requires some thought about how to view it so that important features can be seen, especially if there is only one flower visible in the illustration. If there are several flowers, it may be possible to show examples of front, back and side views.

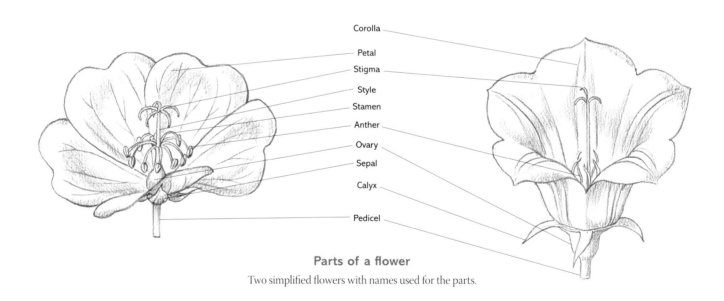

Parts of a flower

Two simplified flowers with names used for the parts.

The structure of a simplified flower

The flower is the reproductive part of the plant, where seeds will form. Within it are the stamens containing pollen and the ovary with a style for catching pollen. These are surrounded by petals and sepals or corolla and calyx. The flower is attached to the plant by a stalk called a pedicel and it may be part of an inflorescence of more than one flower.

Flower shapes

The overall shape of a flower may resemble a shallow dish, a bowl or a tube curving either outwards or inwards at the rim. When shading for three dimensions, a light source from one side or the other will provide shadows to copy. The shapes below are lit from the left-hand side.

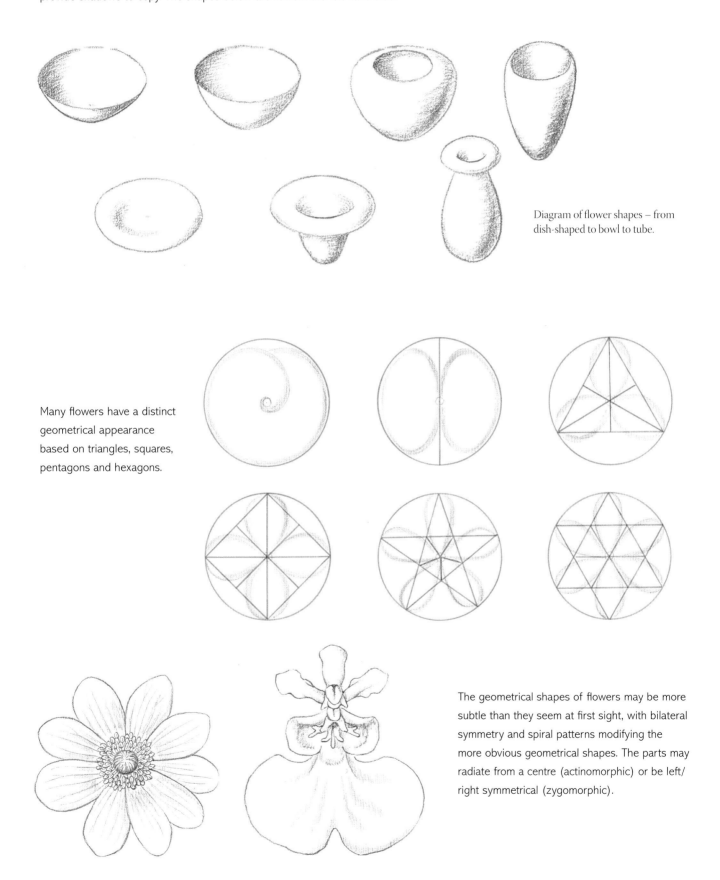

Diagram of flower shapes – from dish-shaped to bowl to tube.

Many flowers have a distinct geometrical appearance based on triangles, squares, pentagons and hexagons.

The geometrical shapes of flowers may be more subtle than they seem at first sight, with bilateral symmetry and spiral patterns modifying the more obvious geometrical shapes. The parts may radiate from a centre (actinomorphic) or be left/ right symmetrical (zygomorphic).

Theory and reality

The theoretical flower shapes on the previous page are useful only as an aid to distinguishing basic shapes and symmetries. In reality, few flowers can be found which actually fit these simple designs, because most are based on more subtle patterns. This is why it is important to draw what you see rather than trying to iron out any inconsistencies. If possible, examine a number of flowers to see whether features recur in all the flowers on a plant.

Top row: *Zantedeschia aethiopica*, *Begonia dregei* male flower, *Tradescantia virginiana*. Second row: *Clematis montana*, *Viburnum tinus*, *Scilla sibirica*.

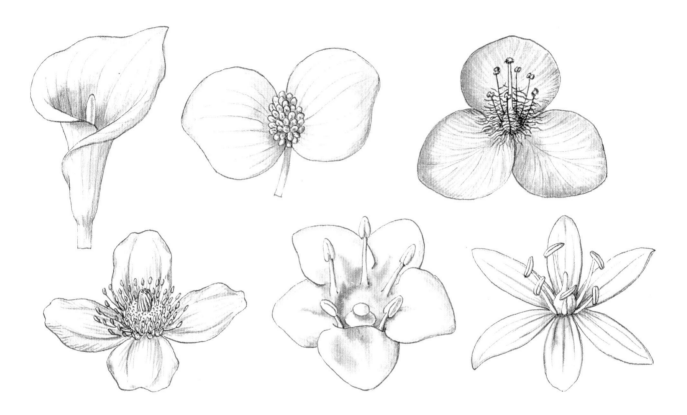

Some flowers may have a rotational twist to the petals, either in their shape or in how they overlap. Others may be partly asymmetrical because not all the petals are similar in size or shape.

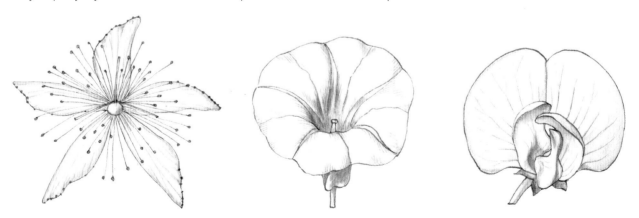

Hypericum perforatum and *Calystegia sepium* flowers with a rotational twist and *Lathyrus latifolius* with asymmetrical lateral petals.

All the flowers on this page have been scaled to roughly the same size for comparison.

One or more flowers on a stem

One flower on a stem is a simple situation, but many plants have inflorescences with several flowers. These are an interesting challenge to draw as the perspective and light and shade must be correct for each flower as well as for the inflorescence as a whole.

It is important that a flower is joined to its stem correctly. To make sure all the parts meet where they should, lightly sketch in the invisible parts as if the flower were transparent and remove the lines when it looks correct.

Diagram of an inflorescence with several flowers represented as circles, to show the effect of perspective. The circles become ellipses when seen from an oblique angle.

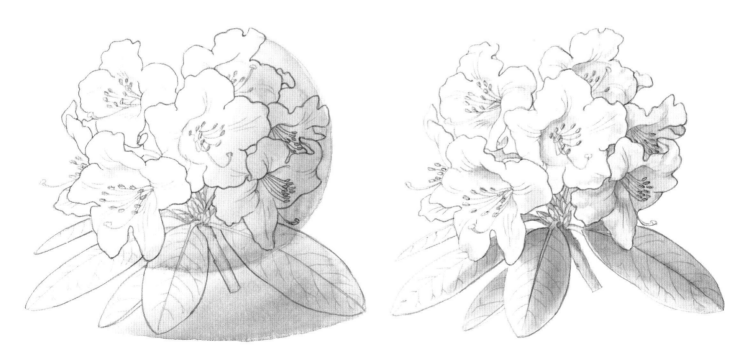

Rhododendron campylocarpum

The drawing on the left is shaded as if it were a solid object. On the right is the same drawing shaded as it would actually be painted. A pale shadow tone has been applied to flowers on the right to give the inflorescence as a whole a rounded appearance.

Colours for flowers

It is difficult to match the freshness and brightness of flower colours with paints on paper, even with the enormous number of shades of watercolour there are to choose from. First, make sure that your brushes and paints are absolutely clean because even a small amount of contamination can spoil the colour. The water must be clean also and it is a good idea to have separate jars for washing the brush and for using to mix the colour. Make experimental mixtures to match the flower colour before finding a mixture with which to paint the shadows. The colour for the shadows makes a big difference to the impression given of the texture of the flower.

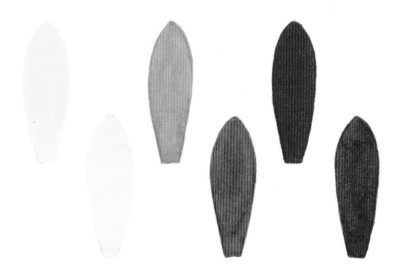

A selection of colours useful for flower petals

From left to right, above: cadmium lemon, cadmium yellow, cadmium orange, scarlet lake, ruby red, permanent alizarin crimson.
Below: permanent rose, permanent magenta, carbazole violet, French ultramarine (red shade), cobalt blue, Winsor blue (green shade).

The shade chart opposite shows some useful colour mixes for petals, and the details are in the right-hand column on this page. The numbers in brackets are the number of washes.

Opposite page
Top row, yellow to orange:
A: cadmium yellow + cadmium orange;

B: cadmium orange;

C: cadmium orange + scarlet lake;

D: scarlet lake (2)+ cadmium yellow;

E: cadmium orange + scarlet lake + perylene maroon;

F: permanent alizarin crimson + cadmium orange (2).

Second row, red:
G: scarlet lake (2) + permanent rose;

H: permanent alizarin crimson (2) + scarlet lake;

I: permanent alizarin crimson + permanent magenta (2);

J: permanent alizarin crimson (3); K: perylene maroon + permanent alizarin crimson (2);

L: neutral tint + permanent alizarin crimson (2) + permanent magenta.

Third row, pink and purple:
M: permanent magenta;

N: permanent magenta + permanent rose;

O: permanent rose + carbazole violet (2);

P: permanent magenta + carbazole violet (2);

Q: carbazole violet (2);

R: neutral tint + permanent alizarin crimson (2) + permanent magenta.

Bottom row, blue:
S: French ultramarine (red shade) (3);

T: French ultramarine (red shade) + carbazole violet (2);
U: cobalt blue (3);

V: French ultramarine (red shade) +Winsor blue (2);

W: carbazole violet + French ultramarine (red shade) (2);

X: neutral tint + carbazole violet + French ultramarine (red shade).

Colour mixtures for petals

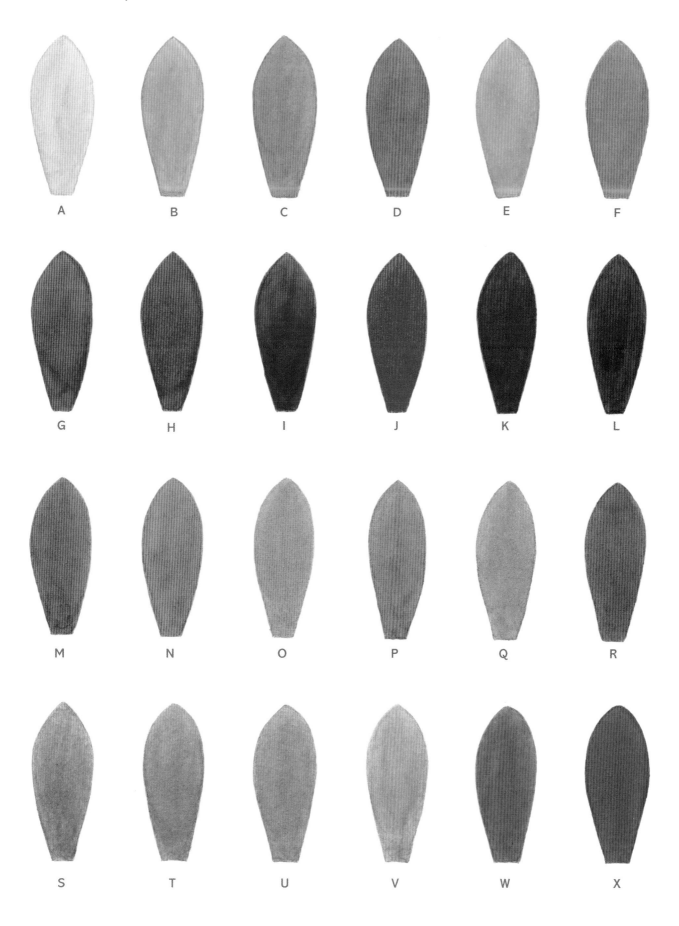

Shadow colours for flowers

The following series of petals with shadows offers suggestions of colour mixtures to try out. The shadow colour can be applied before or after the petal colour, but with darker colours, care must be taken not to dislodge previous layers of paint. The colour mixtures described in the captions are in the shadow areas only.

Top row:

A: neutral tint;

B: neutral tint + perylene maroon;

C: neutral tint + aureolin;

D: neutral tint + aureolin (2);

E: cadmium yellow +(Winsor blue green shade+perylene maroon);

F: permanent magenta + cadmium orange.

Middle row:

G: neutral tint;

H: permanent magenta;

I: permanent magenta;

J: permanent magenta;

K: permanent magenta;

L: permanent alizarin crimson.

Bottom row:

M: permanent alizarin crimson + ruby red;

N: permanent alizarin crimson;

O: permanent magenta + carbazole violet;

P: carbazole violet + permanent magenta;

Q: Winsor blue (green shade) + carbazole violet;

R: Winsor blue (green shade) + carbazole violet.

Very dark colours

Neutral tint is useful as a component of very dark reds, purples and blues; however it also has the effect of making the colour dull. A glaze of bright, transparent colour laid over the top may brighten it up. The cadmium colours are opaque and not suitable for glazes, but permanent alizarin crimson, permanent rose and permanent magenta work well. It is better to apply the colour in many thin washes when aiming for a dark colour rather than using more concentrated paint. Otherwise the base layers may lift off and result in an uneven surface. Among blue colours, French ultramarine and cobalt blue are both difficult to manage in high concentrations. Indanthrene blue may be easier to manipulate.

Base layer: neutral tint + permanent alizarin crimson + ruby red.

Shadow colour: carbazole violet + permanent alizarin crimson.

Base layer: neutral tint + permanent magenta + permanent rose.

Shadow colour: carbazole violet + permanent alizarin crimson.

Petals with more than one colour

When petals have zones of different colours, each colour should be applied separately using a brush with clean water to soften the edge and leaving it to dry thoroughly between the colours.

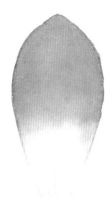

Carbazole violet, cadmium yellow.

Scarlet lake, cadmium yellow, (cadmium yellow + indigo).

Permanent rose, cadmium yellow, (cadmium yellow + Winsor blue green shade).

Capturing flower texture

The texture of a flower refers to the quality of the overall impression that is seen. It may be the result of the size of flowers, the number of petals, the petal surface or coloured spots and markings. Textures can be portrayed using a combination of drawing and painting. Pencil lines add definition to coloured textures, and gouache can be used to apply hairs or other details on top.

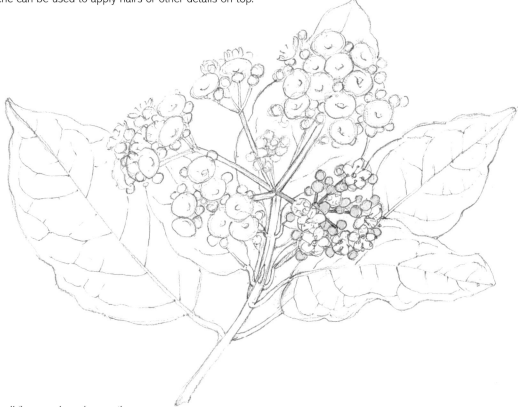

Viburnum tinus

An example of a subject with small flowers where the pencil lines of the drawing have been used to create the texture of the inflorescence. At the preliminary stage of the drawing (above) the position and size of some of the flowers were indicated by a circle. Details of the petals and stamens were then added and some colour (below), taking care to leave enough white paper for the overall effect to remain white and not grey.

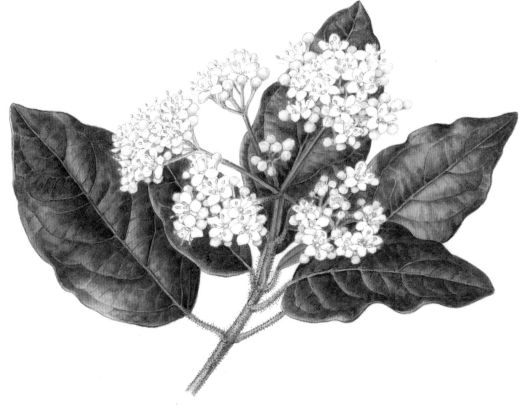

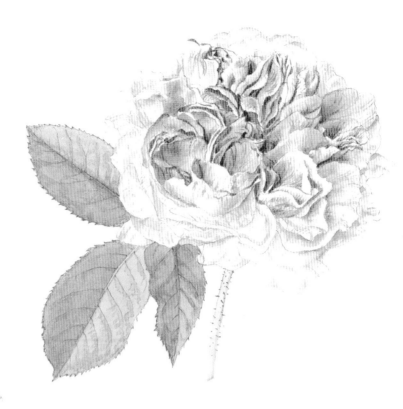

Rosa damascena, a fully double rose with many small petals

The small component petals must have an outline so that shading against the lines can be used to indicate depth. Avoid grey in shadow colours.

The centre of Leucanthemum maximum (Shasta daisy)

The centre consists of many tiny florets. Pencil lines can be used to indicate the shapes of these.

Hypericum calycinum (Rose of Sharon); a flower with many stamens

The stamens in the centre of a *Hypericum calycinum* flower need some pencil lines to give the effect of separate stamens and to define the anthers.

69

Crinkly petals

The creases which give poppies (*Papaver rhoeas*) a crinkly texture can be painted as brush strokes with sharp edges.

Hairy surfaces

The hairs on a *Pulsatilla vulgaris* flower (Pasque flower) give it a silky texture. Fine brushwork using the basic petal colour may give an impression of hairs, otherwise white gouache can be used.

Waxy bloom

The dark red flowers of roses often have a bloom which is seen as a greyish colour. If this colour is applied first, the actual colour can then be shaded into it. It may take several layers of colour to capture the intensity.

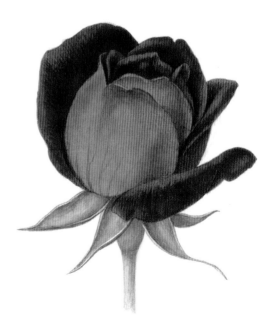

Spots and markings

It is best to paint the overall colour of a flower before applying spots and markings, so that they remain sharp. Pencil guidelines can be used if the markings are dark enough for them not to show through the colour. A dip pen with a fine nib can be used with watercolour (use a brush to fill the pen) for making round spots, rather than a pointed brush, which tends to make triangular marks. A brush can be used for lines and other effects.

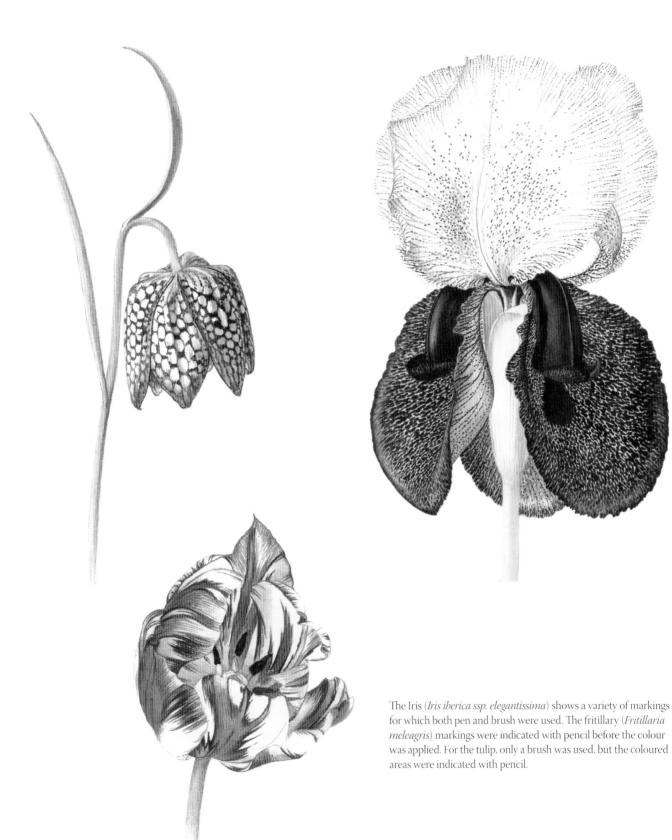

The Iris (*Iris iberica ssp. elegantissima*) shows a variety of markings for which both pen and brush were used. The fritillary (*Fritillaria meleagris*) markings were indicated with pencil before the colour was applied. For the tulip, only a brush was used, but the coloured areas were indicated with pencil.

Floral details

Many flowers cannot be fully appreciated without a magnifier or a microscope, but when enlarged, their diverse and sometimes intricate structures can be seen. There are floral 'platforms' for insect pollinators to land on, coloured spots and stripes to guide them to nectar and hairs and protuberances to limit their foraging. Pollen from catkins blown in the wind is caught on the feathery styles of tiny tree flowers. These features can be drawn at a magnified scale to complement a drawing of a plant at natural size.

The simplest floral detail is a single flower drawn larger than life-size. Front and side views can be drawn to show more of the shape and parts can be drawn separately.

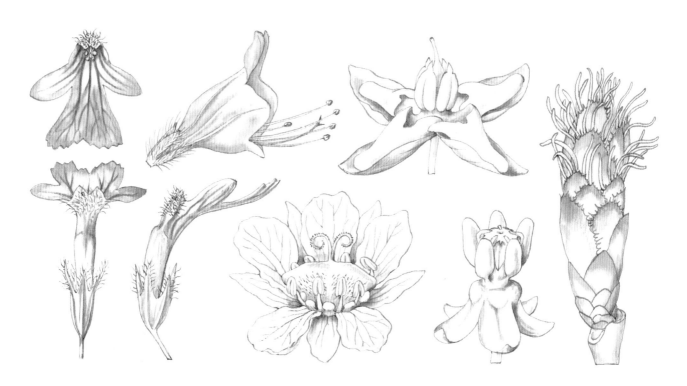

Above, left to right in top row: *Ajuga reptans,* front view;
Echium vulgare, side view; *Epimedium alpinum.*
Bottom row: *Ajuga reptans,* from above and side view;
Acer davidii; Asclepias barjoniaefolia; Carpinus kawakami.

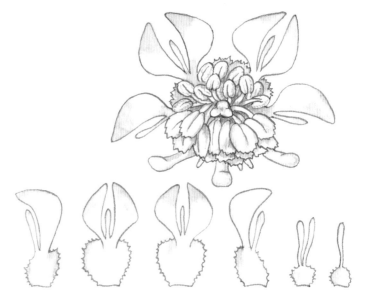

Right: A flower of *Reseda lutea,* drawn ten times life size. The stamens shrivel and become smaller after the pollen is released. The petals show a range of different shapes and sizes.

Arranging and annotating floral details

There are some conventions about how floral details are drawn, to facilitate comparison and to ensure they can be easily understood.

• Parts (or whole flowers) are arranged vertically with the point of attachment at the bottom
• Cut edges are shown by a double line (or sometimes a dotted line)
• The order in which parts are listed is from vegetative (roots, shoot, leaves) to reproductive (inflorescence, flower, parts of flower, seed)
• The parts of the flower are listed from the outside inwards (bracts, sepals, corolla, petals, stamens, style and ovary)
• Parts which are curled or concave are drawn flattened out
• A bar scale or magnification is included to provide a means of estimating the actual size of parts

Parts arranged vertically

It may seem strange to see flowers which normally hang down, for example the *Epimedium* flower on the opposite page, viewed the other way up with the stalk at the bottom. This is not a hard and fast rule; the *Echium* flower to the left of the *Epimedium* is seen sideways. The point is that arranging the parts in an orderly manner gives a neat and tidy appearance to a page of floral dissections.

Double lines to show cut edges

It is necessary to be able to tell the difference between the natural edge of a feature and a cut edge. The use of double lines for cut surfaces makes it possible to distinguish where parts have been sectioned or removed. With a half-flower section, the boundary of the cut surface should be a continuous line, as in the *Aristolochia* half-flower section on page 74. Sometimes a dotted line is used for a cut edge if it seems clearer.

Bar scales

Bar scales and captions provide the viewer with information about the actual size of the magnified details. Measurements may be in metric or imperial sizes. The table of metric bar scales below shows how several lines can be used to indicate a multiplication factor. This convention can be used for increasing or decreasing sizes, from flowers up to trees and from flowers down to microscopic structures, but captions are needed to state what sizes the bar scales are equivalent to. Care is needed when calculating the size of bar scales.

A useful bar scale is 25mm, which is more or less equivalent to 1in, thus making it possible to give a scale which shows both metric and imperial sizes. If using several lines, the factor of 10 could still be used, giving 10in, 1in and $^1/_{10}$in, equivalent to 25cm, 25mm and 2.5mm.

	Bar Scales			
Reduction				Magnification
x 1	2cm		2cm	x 1
x ½	4cm		2mm	x 10
x 1/3	6cm		1mm	x 20
x 1/500	1m		0.5mm	x 40

Floral details of *Begonia dregei*

This Begonia has flowers which are either male or female. The parts of the flowers can be separated and drawn to scale, needing only a cut section of the ovary, which is shown from the side and in section. Nearby is a further enlargement of the cross section to show the ovules.

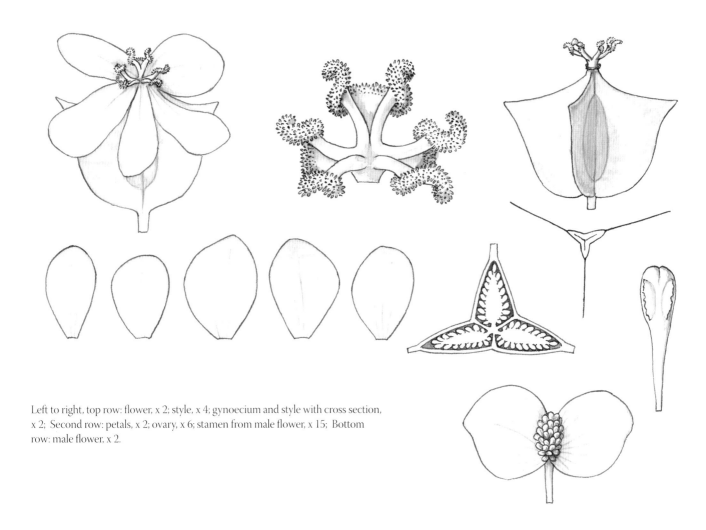

Left to right, top row: flower, x 2; style, x 4; gynoecium and style with cross section, x 2; Second row: petals, x 2; ovary, x 6; stamen from male flower, x 15; Bottom row: male flower, x 2.

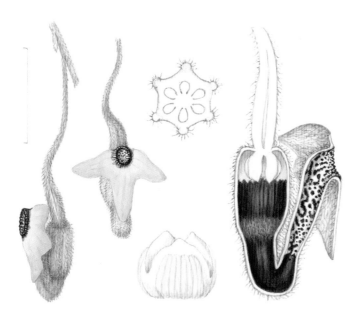

Aristolochia sp.

The strange, tubular flowers of this plant are green on the outside but have markings on the inside which cannot be seen without cutting it open. Two flowers are shown life size, but the half-flower section is x 2. The section of a young seed pod shows that it has six locules and below that is a detail of the stamens. The bar scale represents 25mm (1in).

Cutting a half-flower section

A half-flower section is a good way to illustrate the internal structure of flowers. Before cutting a flower in half, look carefully at the symmetry to see where to make the cut. The diagrams (right) show cut lines in red.

The cut line has to pass through the central axis of the flower. If the flower has an odd number of petals, the cut line will pass through a petal on one side of the central line and between petals on the other side.

There are two ways to cut a flower with an even number of petals. The cut line must pass through the central line but it can either pass through petals or between petals on both sides of the central line.

Flowers which are zygomorphic, with two sides which reflect each other, can be cut longitudinally through the line of symmetry. No other line will give two equal halves.

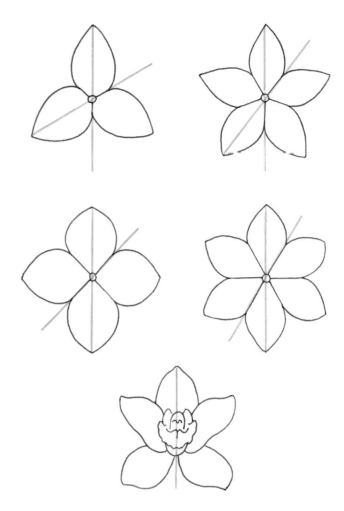

Making the section

A sharp razor blade or craft knife is needed to cut plant tissue without tearing it. The parts must then be kept moist in a dish of water or they will become shrivelled and difficult to draw. Have a number of flowers to use because practice is necessary, especially if the flowers are small and delicate.

A *Cymbidium* half-flower

Cymbidium orchids are widely available from florists and are good subjects for floral dissection because the tissue of the petals is thick and firm.

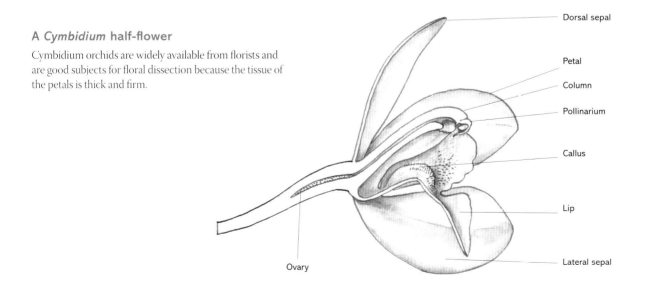

A half-flower in colour

A coloured half-flower section is an interesting way to explore the internal structure of flowers. The cut surfaces can be left pale against the coloured interior. The drawing may need to be big enough to show parallel lines of features such as stamens without confusion.

Billbergia nutans

A plant of the Bromeliaceae family from South America.

A, inflorescence, x 1; B, half-flower x 3; C, detail of base of corolla, x 6; D, stamen, x 6; E, apex of style, x 9; F, transverse section of ovary, x 6.

Alternative ways of cutting a section of a flower

Sometimes flowers are shown with only part cut away, or one petal rather than half of the flower.

The flowers of plants of the *Lamiaceae* family can be cut by separating the upper and lower halves of the corolla, as with *Salvia caymanensis* shown here.

A, corolla side view, x 6

B, corolla upper half, x 6

C, corolla lower half, x 6

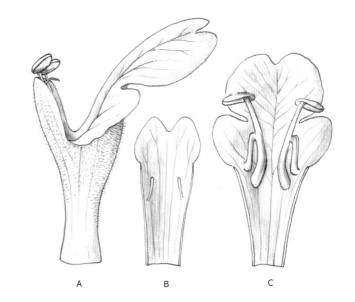

Tecophilaea cyanocrocus

At first sight the flowers of this rare bulb from Chile seem to have six equal petals. However when examined and sectioned, the flowers are seen to be zygomorphic, with only three fertile stamens out of six and differences in colour and hairs at the base of the petals. The upper half and lower half of the flowers are shown separately.

A, flowers and leaves, x 1; B, lower half of corolla and fertile stamens, x 6; C, upper half of corolla, x 6; D, three fertile stamens, x 9; E, sterile stamen, x 9 and detail of apex, x 18; F, stigma, x 40 ; G, transverse section of ovary, x 9.

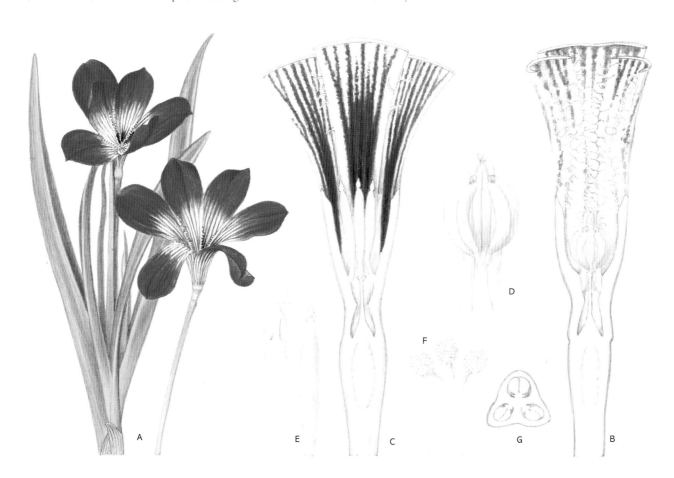

Using a microscope

The extra magnification a microscope provides makes it possible to explore the details of plant structure further than with a lens on a stand or a magnifier. A binocular microscope is comfortable to use and leaves both hands free for making dissections. A typical model has eyepieces which magnify ten times and an objective (a series of lenses inside the lower part of the microscope) which can be zoomed from x 0.6 to x 4. Together, these give the possibility of up to x 40 magnification. There will be a built-in or separate light source which can be arranged at different angles and dimmed or brightened. A measuring device, or graticule, can be installed in the eyepiece which can be used to check proportions and to measure the size of objects. Some microscopes have a camera lucida facility which enables a virtual image to be projected onto a piece of paper at the side of the microscope. The image can then be traced with a pencil without any need for interpretation. The resulting drawing usually needs some neatening for publication, but is as close as possible to the object drawn.

A Kew microscope with a camera lucida.

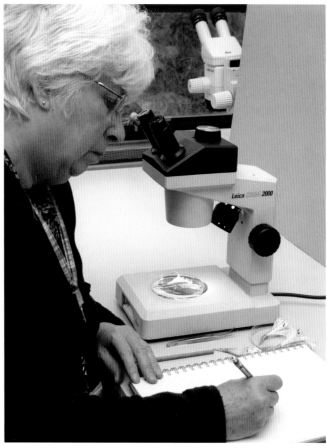

The author drawing an *Alstroemeria* half-flower with the help of a binocular microscope.

When drawing without a camera lucida, a graticule in one of the eyepieces enables objects to be measured. If the graticule has a grid of squares, it is possible to work out how big each square is by looking through the microscope at a ruler with marked divisions, either millimetres or inches. Some graticules are just a line with divisions, but this is still useful for making measurements, as you can rotate it in the eyepiece to match sizes on the object in view.

Having measured the object you want to draw, you must decide how big the image drawn on paper is to be; for example, whether it needs to be x 6 or bigger to enable details to be visible. If your illustration is for publication, you might also need to take into account any reduction in size during the printing process.

The use of bar scales avoids the problem of calculating magnifications, by showing a line representing, for example, 5mm, 1mm or 0.5mm next to the drawing (see Bar scales on page 73). The viewer can then easily see how big the object drawn actually is. At high magnification, it may be difficult to see accurately how big an object is, in which case the caption can say 'highly magnified'.

A spiral-bound sketchbook is useful for microscope drawings, because you can turn the cover back so that it takes up less space. Bound sketchbooks look good but are often inconvenient to work in because the pages cannot be turned back.

To begin the drawing, make vertical and horizontal lines and mark the greatest length and width on these. The outline can be drawn using these points, and further measurements made to help complete the drawing.

Label the drawing with the name and the magnification or draw a bar scale as soon as possible, as it is easy to forget to record this important information.

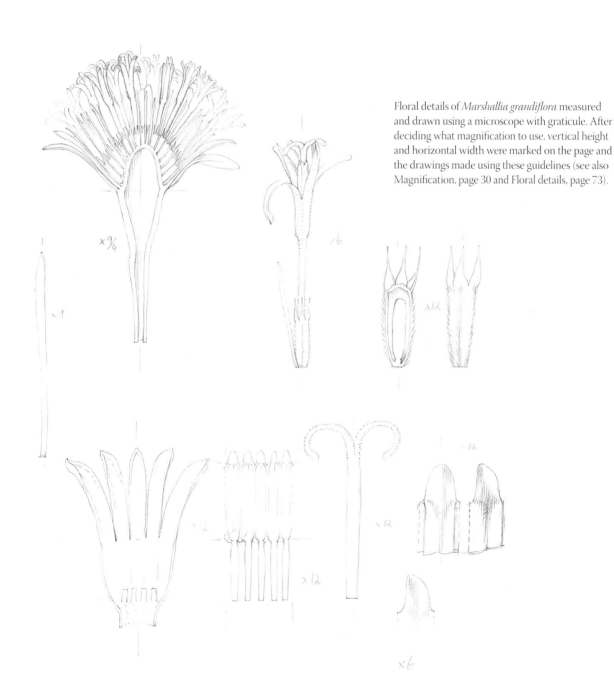

Floral details of *Marshallia grandiflora* measured and drawn using a microscope with graticule. After deciding what magnification to use, vertical height and horizontal width were marked on the page and the drawings made using these guidelines (see also Magnification, page 30 and Floral details, page 73).

Preserving specimens

Plant specimens which have been carefully pressed and dried keep all their features except their colour. The Herbarium at Kew has about seven million pressed specimens from all over the world, mounted, labelled and filed in cabinets, which provide an invaluable source of reference for research. Line drawings are made from these specimens to illustrate botanical journals, books and floras.

Pressed plant material lasts indefinitely, and there are many specimens in the Herbarium made in the nineteenth century, which are still in good condition. The names of plants depend on published descriptions of a named type specimen as the representative of a species.

Three pressed and mounted herbarium specimens of *Epimedium* species from China. *E. lishihchenii* (left and centre) was collected by M. Ogisu in 1996 and *E. acuminatum* (right) was collected by E. H. Wilson on Mt. Omei in 1905.

Specimens can also be preserved in a fluid which keeps their three-dimensional appearance. At Kew, orchid flowers are often preserved this way. The fluid used is called Copenhagen mixture and consists of 70% industrial spirit (ethanol), 29% water and 1% glycerol. Specimens can be preserved for a short while (a month) in methanol and water or, if nothing else is available, in vodka.

Sometimes it is useful to make a pressed specimen of a plant to refer to if an illustration cannot be finished quickly. The best way is to arrange the plant flat between sheets of blotting paper and put it in a plant press to dry out, remembering to include a label with the name and date it was pressed. The blotting paper can be changed every few days until the specimen has dried out. If the specimen is difficult to flatten out, pieces of folded paper can be used as padding around thick stems and leaves to level them. Newspaper can be used instead of blotting paper. Small specimens of flowers or leaves can be pressed between sheets of paper inside a paperback book or under a pile of heavy books.

A Kew plant press as used on expeditions. It is not difficult to make a similar one using stripwood and panel pins.

When the specimen is dry, it can be kept in a folded sheet of paper with a label to identify it, or it can be stuck onto thick cartridge paper with PVA glue. A box file is suitable for keeping small pressed specimens.

Box file with pressed specimens in folded layout paper.

Working from pressed specimens

A drawing made from a flat pressed specimen is bound to be somewhat unnatural looking, but its purpose is primarily to display the botanical features clearly and so the drawing should show the specimen exactly as it is. If it is damaged, the broken edge can be shown as a dotted line rather than attempting reconstruction. If there are photographs of the live plant, it may be possible to give the drawing a slightly more natural look, but the shape of the specimen should still be strictly adhered to. When drawings are commissioned, a botanist will draw up a brief for what should be included and how it should be done, to guide the illustrator.

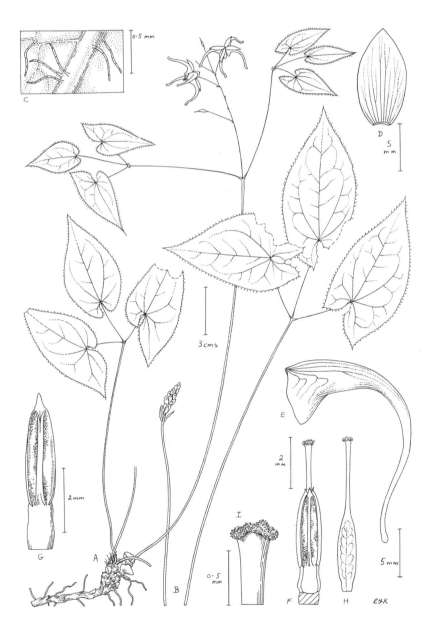

Epimedium lishihchenii **Stearn**

Fig. 47 from *The Genus Epimedium* by W. T. Stearn (RBG Kew 2002).

This drawing was made from the two specimens, left and centre, in the photograph on page 80. The left-hand one is the holotype for the species, which means that the species name is defined with reference to this particular specimen. No attempt to reconstruct imperfections was made but dotted lines were used for the broken edges of leaves. A technical pen was used for the ink drawing.

Detail 'I' at the size it was drawn.

The shape of the specimen is drawn using dividers to measure it and check that the proportions are correct. Preliminary drawings can be made on tracing paper and then arranged within the given page size. When the design is satisfactory and has been checked by the botanist who commissioned the illustration, it can be transferred to line drawing paper and inked in. An illustration may include a same-sized drawing (x 1) of a representative portion of a specimen, with enlarged drawings of important details arranged around it.

Most frequently, illustrations are drawn within an area one and a half times the size of the page, to be reduced when printed. This is known as 'half-up'. Sometimes, when many drawings are to be fitted into a page, the illustration can be made within an area twice the size of the page. The sizes of parts illustrated are shown either with bar scales or with lettering and captions.

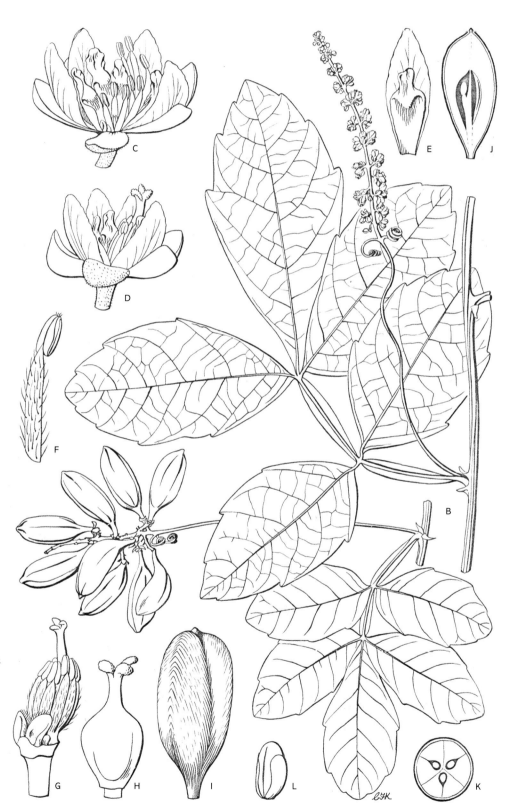

Paullinia pinnata L

Fig. 26 from _Flora of Tropical East Africa, Sapindaceae_ by F. G. Davies and B. Verdcourt, RBG Kew 1998.

An illustration of a woody liana which has male (C, E, F) and female (D, G, H) flowers on the same plant and woody fruits (J, K). The ink drawing was made using a very fine brush with black waterproof ink. The artwork is about 1½ times the size it is printed here.

Cacti and succulents

These types of plant are often mentioned together, although they may not necessarily be botanically related. As subjects for drawing, they have in common the swollen water-retaining stems (cacti) and leaves (succulents), making them suitable for life in arid regions.

The first stage is to make an accurate study in pencil of the main body of the plant which can be used as the basis for a painting.

Choose a viewpoint which shows the shape of the plant, with the apex where the growing point is, the pattern of ridges and the areoles (where the spines originate). Begin by drawing the height and the width to make the outline, followed by the ribs and the areoles. The direction of the lines of the ribs away from the growing point should help the drawing to look three-dimensional.

The rounded forms of cacti and succulents can be seen best when lit from the side, either left or right, according to which hand you use for drawing. If the light source is arranged carefully, the play of light and shade should help to reveal the form.

If there is too much contrast and the shadows are too dark, a piece of white paper can be used to reflect some light back onto the shadow side.

The spines can be painted over the green stem using gouache. More than one layer may be needed for it to be opaque. Pencil guidelines can be a help in placing the spines correctly.

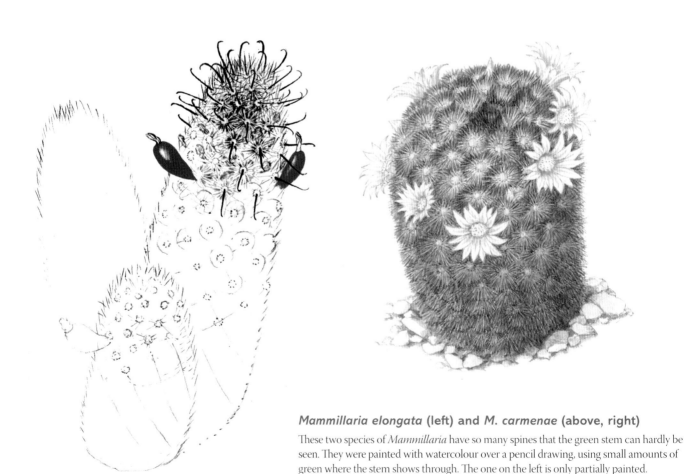

Mammillaria elongata (left) and _M. carmenae_ (above, right)

These two species of _Mammillaria_ have so many spines that the green stem can hardly be seen. They were painted with watercolour over a pencil drawing, using small amounts of green where the stem shows through. The one on the left is only partially painted.

Three stages in a painting of a species of *Ferocactus*

The pencil drawing was made on cartridge paper and then transferred to 300gsm (140lb) smooth Fabriano watercolour paper.

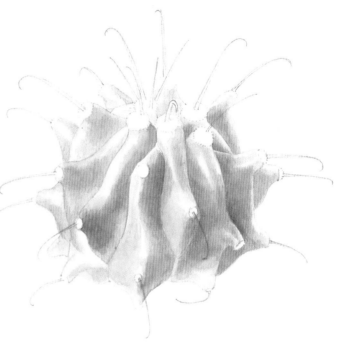

Pale washes of colour were used to show the highlights and shadows. The colours used for the stem were indigo and cadmium lemon with some Payne's gray.

The stem must be completed before the spines are painted over the green colour. Fine brushwork was used to sharpen the detail and increase the contrast. Only a few spines have been painted with gouache so that the high contrast of light and shade on the stem can be seen.

Three stages in the design of an illustration of *Pterocactus gonjianii*

The stages in the design were made on layout and tracing paper. The flowers opened only for a short time and were recorded in a sketchbook.

Stage 1 A very rough sketch done to fit the narrow format.

Stage 2 A more detailed, partly measured sketch.

Stage 3 The accurate drawing used for the painting.

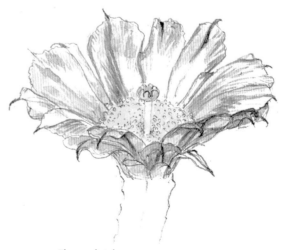

Flower sketch.

Pterocactus gonjianii

Plate 639, *Curtis's Botanical Magazine* Vol. 26 (1 & 2), 2009.

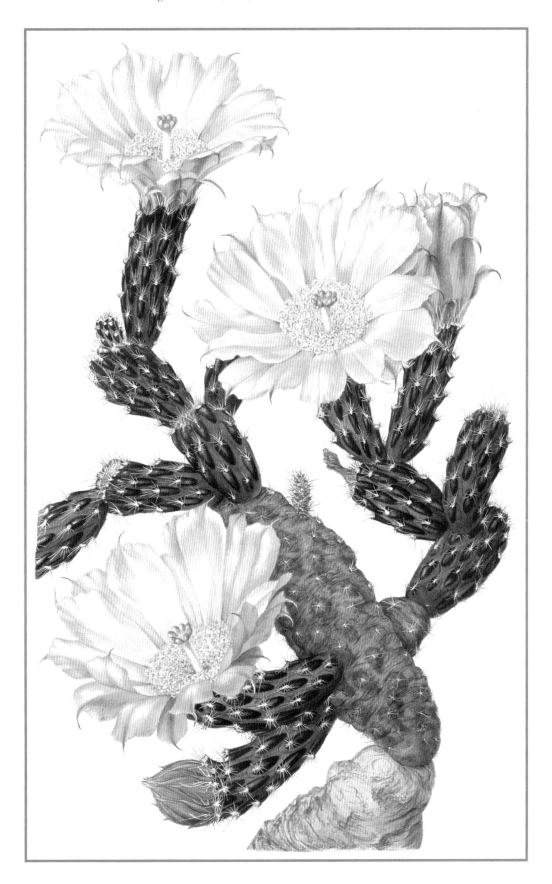

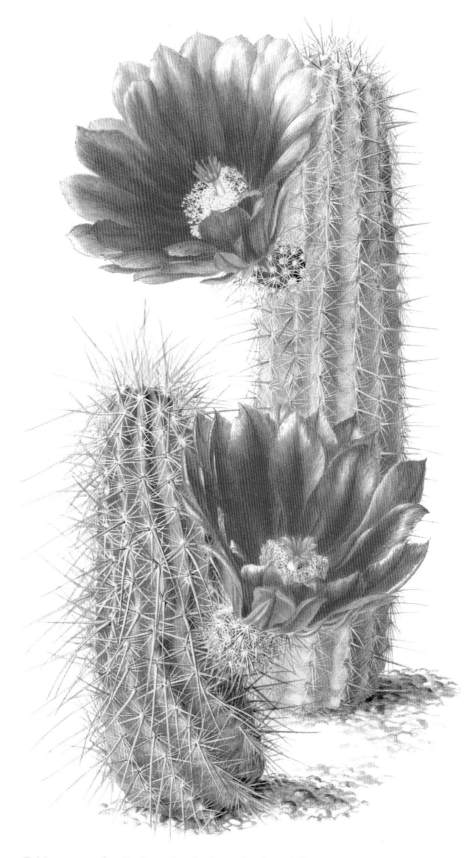

Echinocereus fendleri var. ***fasciculatus*** **(top) and** ***E. engelmannii*** **var.
engelmannii (bottom)**

Plate 1 from *The Genus Echinocereus* by Nigel P. Taylor (Royal Botanic Gardens, Kew, in
association with Collingridge Books, 1985).

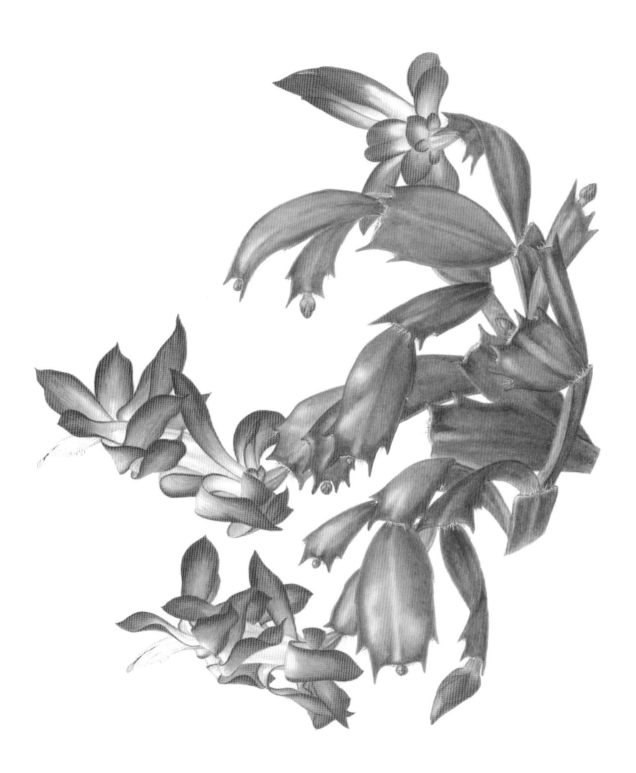

Schlumbergera buckleyi cv.

This autumn-flowering cactus has only a few minute spines. The exotic flowers are zygomorphic and attract hummingbirds, which pollinate them.

Succulents

Succulents have thick fleshy leaves and stems which store water. The smooth leaves of *Pachyphytum* require delicately graded washes of colour to capture the colour and the modelling.

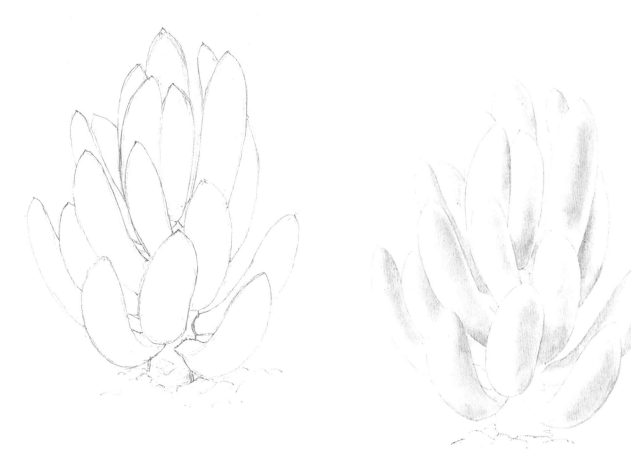

Three stages in a painting of a *Pachyphytum*

The pale green colour was applied in many very dilute washes using mainly Payne's gray, indigo and cadmium lemon with some permanent magenta and permanent rose. Fine brushwork was used to smooth out any uneven colour and heighten the contrast in the shadow areas.

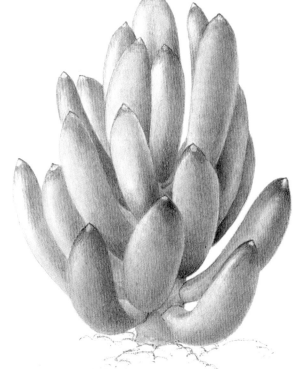

Illustration of *Kalanchoe tomentosa*

The surface of *Kalanchoe tomentosa* is covered in hairs. The texture was built up with many fine brush strokes.

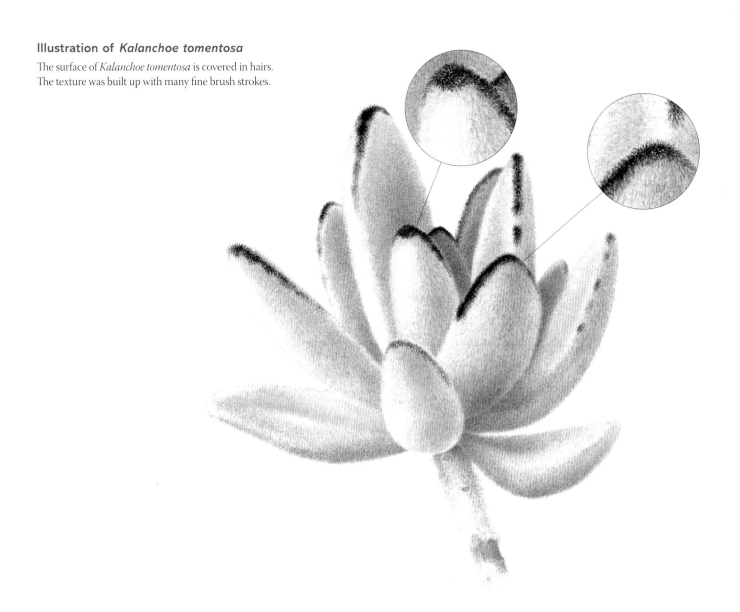

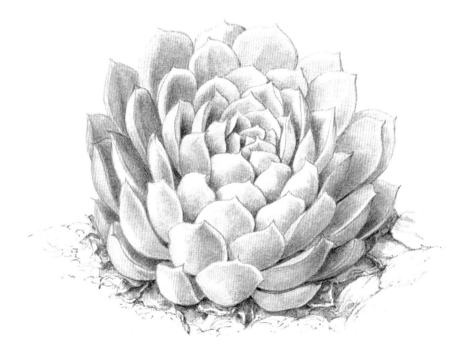

Some *Echeverias* have very pale grey leaves, needing very little colour.

Wild flowers

Wild flowers seem less attractive painting subjects when compared with garden flowers which have been selected for their beauty and decorative value, but when seen at their best in their natural habitat, they have a different type of beauty and a quiet charm.

A wild flower sketchbook

An enjoyable way to study wild flowers is to record them in a sketchbook in pencil and watercolour, annotating them with when and where they were found. The sketches can then be used as material from which to make paintings showing species at different times of year, several species from one locality or a number of species belonging to the same plant family.

The flowers below were all found growing in rough grass locally. From left to right: tormentil (*Potentilla erecta*), knapweed (*Centaurea nigra*), speedwell (*Veronica chamaedrys*), lady's bedstraw (*Galium verum*), autumn hawkbit (*Leontodon autumnalis*) and harebell (*Campanula rotundifolia*).

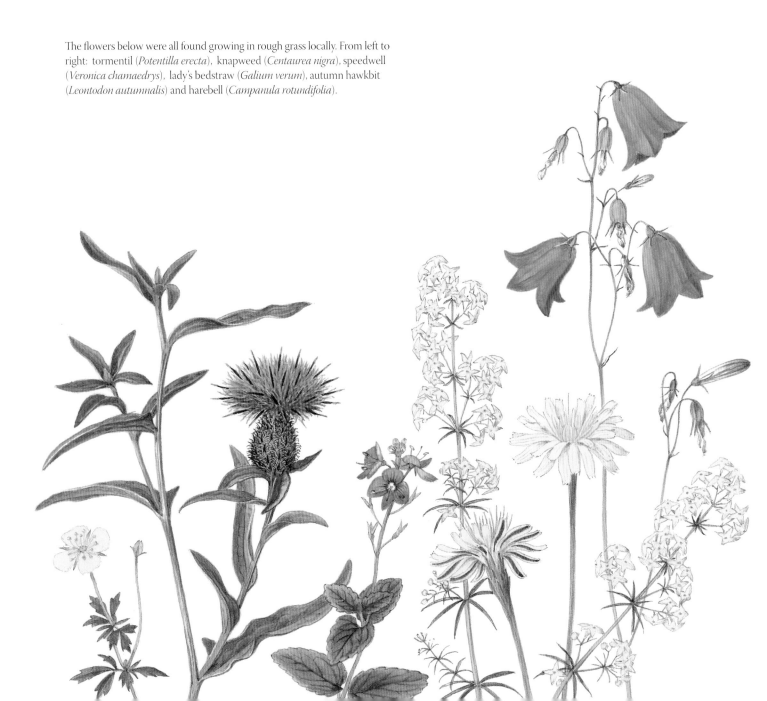

Subjects for this book were recorded in the hardback spiral-bound sketchbook shown below. Most of the plants were found in grassland and on rough ground. The poppy and cornflower (*Papaver rhoeas* and *Centaurea cyanea*) were from a local planted wild flower meadow. The open page of the sketchbook shows Sheep's bit scabious (*Scabiosa columbaria*) and Devil's bit scabious (*Succisa pratensis*) found on the wolds in North Yorkshire.

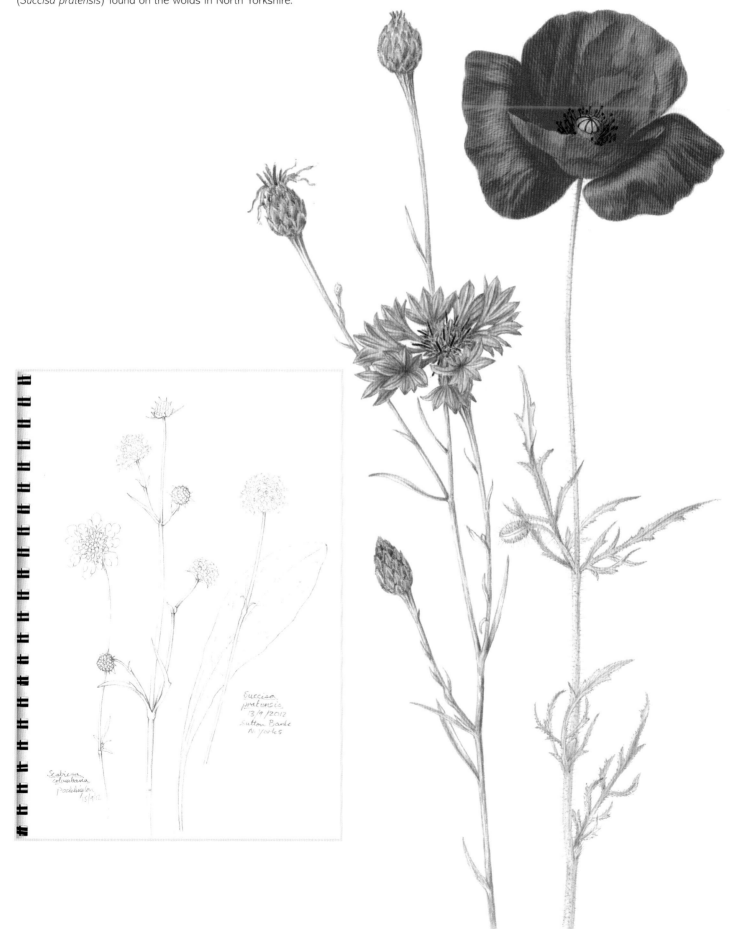

An illustration drawn from collected sketches

The page opposite shows an illustration made up of sketches collected through the summers of 2012 and 2013 in my sketchbook. The design was made by putting each drawing onto tracing paper and then placing them to make a pleasing design for the page. I tried not to change the shapes of the sketches too much but once or twice a leaf or stem was altered slightly to improve the design.

Sketch of Tufted vetch *(Vicia cracca)*

Flowers at different stages were recorded at x 3 using the method with dividers shown on page 30.

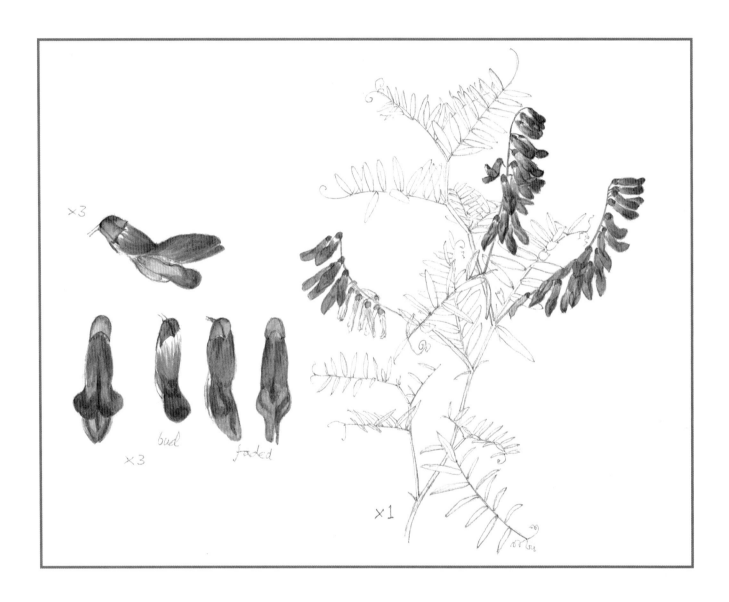

Opposite
Leguminosae

From left to right: Kidney vetch (*Anthyllis vulneraria*), Hop trefoil (*Trifolium campestre*), Red clover (*Trifolium pratense*), Meadow vetchling (*Lathyrus pratensis*), Bird's foot trefoil (*Lotus corniculatus*), Tufted vetch (*Vicia cracca*).

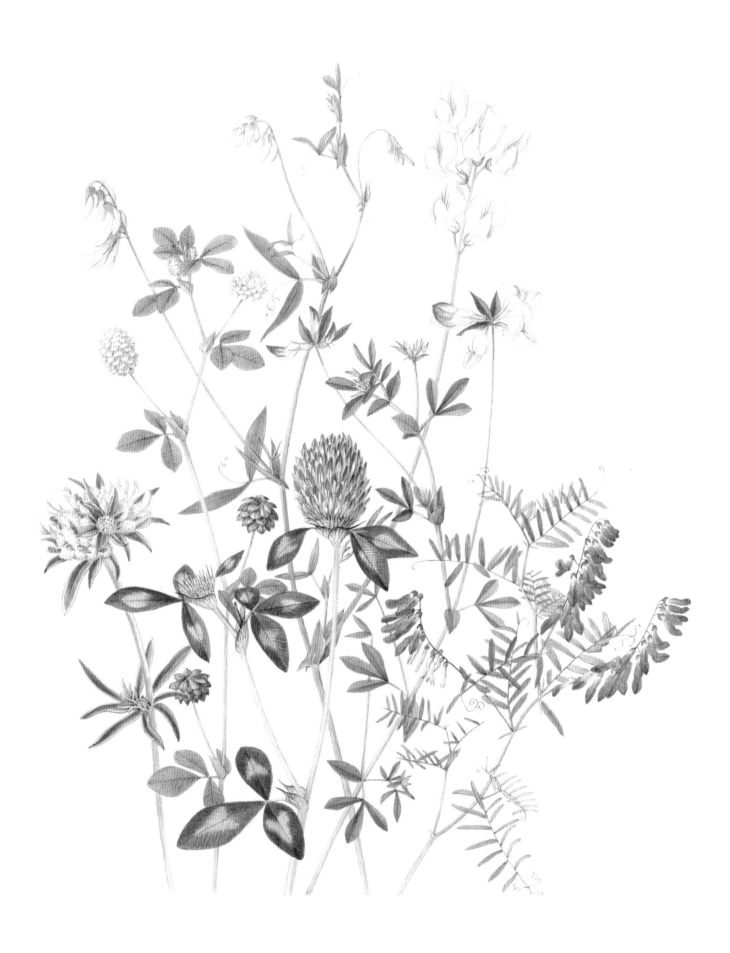

Plants in their habitat

The painting below was made in 1989 and shows a small piece of turf with chalk wild flowers. The need for protecting wild flowers means that permission must now be asked from landowners to collect plants. If you have a garden, an area may be set aside for growing wild flowers which are then close at hand to draw. They grow better on rough ground and do not require good soil to grow in. In fact they may produce leaves rather than flowers on good soil.

When drawing this type of composition, first draw the general shape and then use prominent flowers and leaves as landmarks to place the smaller items.

Flowers in chalk turf

Silverweed (*Potentilla anserina*), Self-heal (*Prunella vulgaris*) and Creeping cinquefoil (*Potentilla reptans*).

Plants growing in soil or stones

Small plants and bulbs may need some indication of the soil in which they are growing if the illustration is to look naturalistic. To be absolutely correct, the soil or stones ought to look authentic, but this is only possible if a sample was collected from the place where the plant grows naturally or if adequate photographic reference is available. In any case, the amount of soil shown around the plant should only be enough to give stability to the design.

A collection of small bags of stones of different types, such as horticultural grit, small pebbles and limestone chippings, provides useful reference for drawing.

Arabis cypria
The plant is shown among Cotswold stone chippings.

Travel drawings

The first thing about drawing on journeys is to simplify your method of working as much
as you can. Your kit should be as lightweight as possible, and ready to use immediately.

My kit is as follows:

Spiral-bound sketchbook; I find that 25.4 x 35.5cm (10 x 14in) is a good size.

A few larger sheets of paper in case they are needed, and masking tape to stick the paper to the board.

A pencil and an A5 pad that can double as a notebook (ballpoint pens are no good on damp paper).

A plastic box or 1.5 litre (2¾ pint) empty plastic water bottle for collecting the specimen.

Floral foam to keep it in position and moist while drawing.

Lightweight drawing board.

Plastic folding palette with about twelve essential watercolour colours.

Selection of sable brushes, with one or two large ones for larger paintings.

Proportional and ordinary dividers.

Selection of pencils, eraser and sharpeners (more than one in case they get lost).

Emery paper pad (important to keep pencils sharp).

Hand lens or lens on a stand.

Ruler and/or measuring tape.

Make sure it is permissible to take a specimen to draw. Take plenty of photographs in case there is some
detail you need which is out of the picture, and put an object of known size, such as a coin or a small
ruler, near the plant to show how big it is.

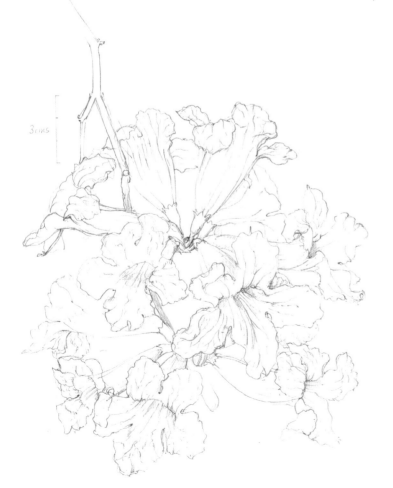

Sketches of
Tabebuia umbellata used to
make the painting opposite.

Tabebuia umbellata

Tabebuia umbellata, known as *'ipé amarelho'* or Yellow trumpet tree, is used as a street tree in São Paulo, Brazil. The leaves were drawn from photographs and a herbarium specimen, as it flowers when there are no leaves on the tree. Pencil outlines seem appropriate to show what shape they are.

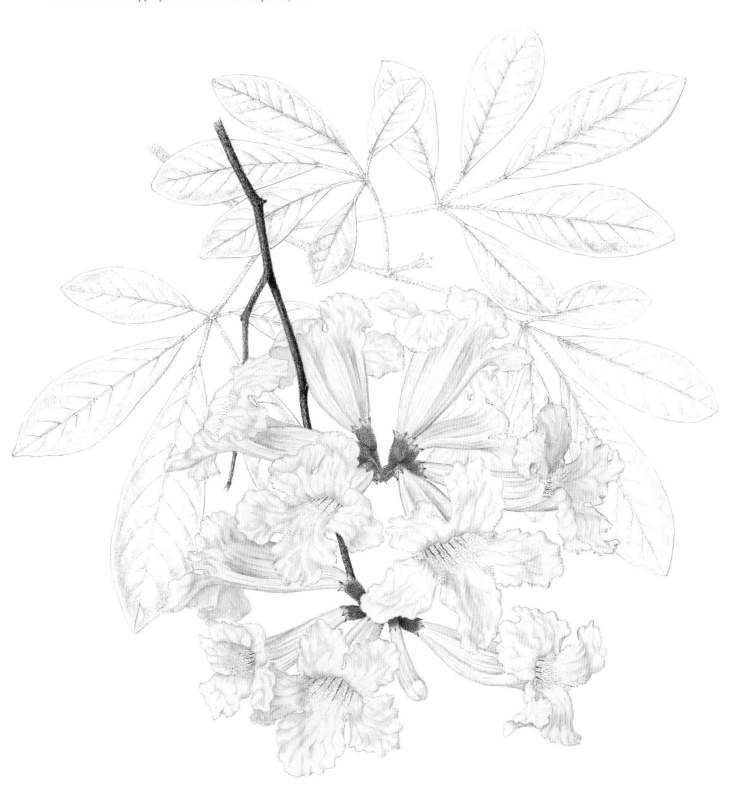

All too often, the most difficult thing is to draw up a painting from your sketches. The only way is to persevere and start again if necessary. This is the second version, made because the flower colour of the first became too orange.

I visited the Ruwenzori Mountains of Uganda in 1987 to make illustrations for the book *Africa's Mountains of the Moon* by Guy Yeoman. Thinking it might be difficult to paint on safari, I made a numbered colour chart, as used by Ferdinand Bauer in the 18th century. The sketch of *Crassocephalum ducis-aprutii* has numbers on it, corresponding to the chart below. In fact it proved quicker to paint some colour on sketches.

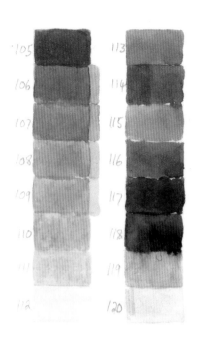

My numbered colour chart.

Crassocephalum ducis-aprutii

Senecio matirolii

Hypericum bequaertii

100

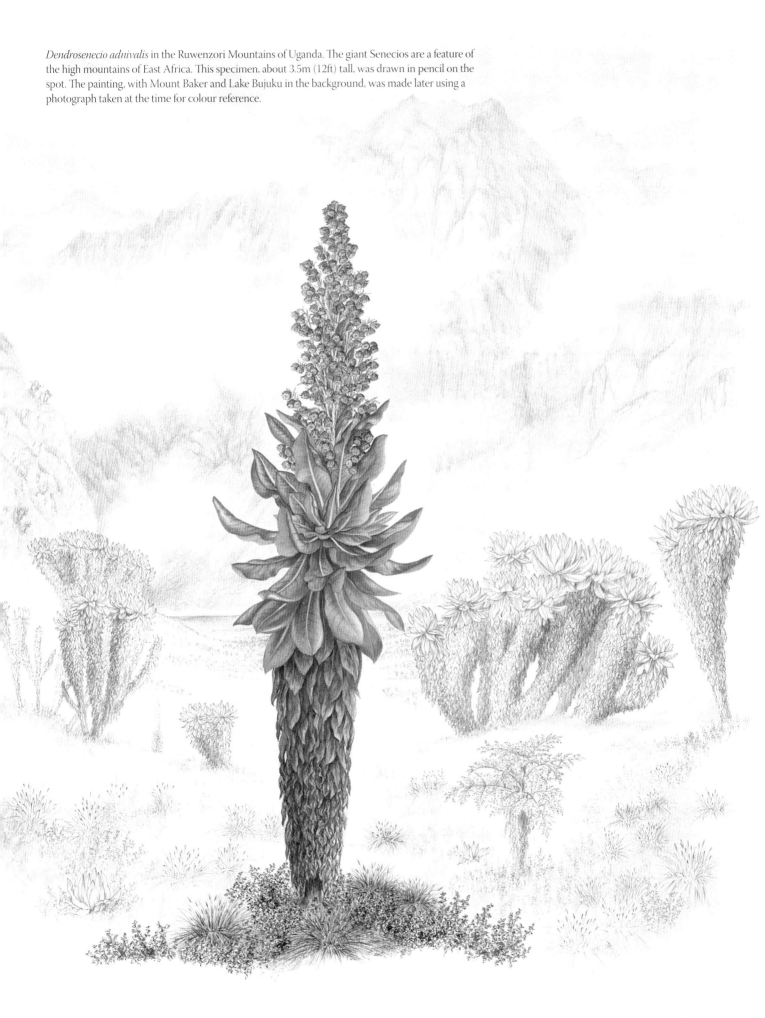

Dendrosenecio adnivalis in the Ruwenzori Mountains of Uganda. The giant Senecios are a feature of the high mountains of East Africa. This specimen, about 3.5m (12ft) tall, was drawn in pencil on the spot. The painting, with Mount Baker and Lake Bujuku in the background, was made later using a photograph taken at the time for colour reference.

Large plants

The inflorescence of this Amazonian shrub was too large to draw at natural size. Large proportional dividers were used to reduce an inflorescence to x $\frac{1}{3}$ and smaller dividers to draw a flower at x 2. The large dividers are 50cm (20in) long and made of stripwood with a bolt and wingnut.

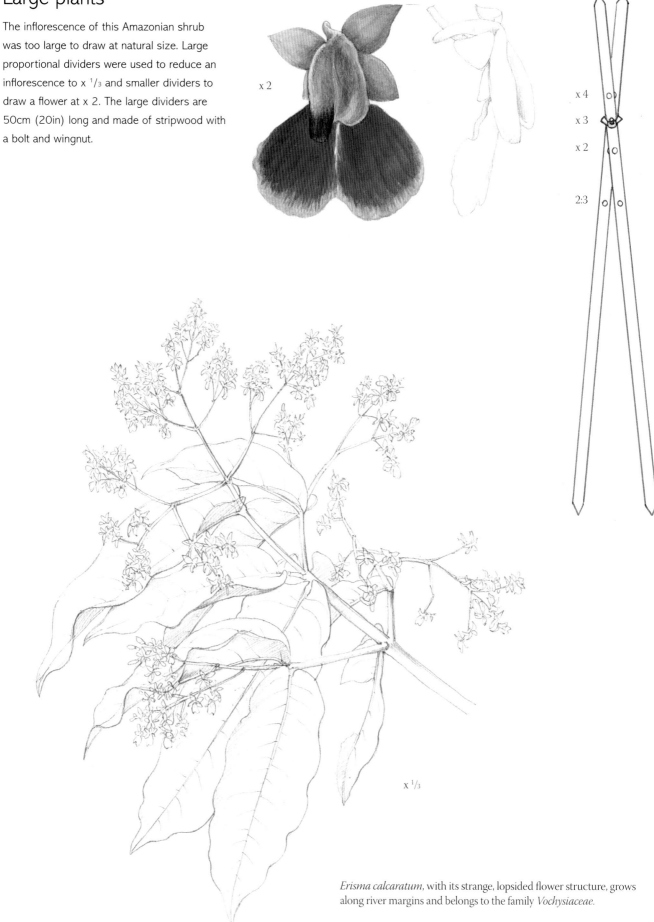

x 2

x 4
x 3
x 2

2:3

x $\frac{1}{3}$

Erisma calcaratum, with its strange, lopsided flower structure, grows along river margins and belongs to the family *Vochysiaceae*.

Calotropis procera

This eye-catching grey-leaved shrub grows on the sea shore near Dar es Salaam in Tanzania. When examined closely, the complicated structure of its flowers shows that it belongs to the plant family *Asclepiadaceae*, now included in *Apocynaceae*. A detailed drawing made while teaching a course there in 2005 was the basis for this painting.

Curtis's Botanical Magazine

The first parts of this periodical were published in 1787 and it still continues, which makes it the longest running magazine of its type with coloured illustrations. William Curtis, who founded the Magazine, trained as an apothecary but left the profession in his twenties to devote his time to natural history. His first publications were entomological but he acquired land to plant a botanical garden and then began his first big project, the *Flora Londinensis*, in which wild flowers found within ten miles of London were illustrated with folio-sized plates. With each illustration, there was some text about the plant and its name according to the Linnean system of biological classification. Despite the beauty of the illustrations, which were made by William Kilburn, James Sowerby and Sydenham Edwards, and a list of 318 subscribers, the project was not financially successful. Curtis then had the idea of publishing information about garden plants in a smaller format periodical, *Curtis's Botanical Magazine*. To begin with, this came out on the first day of every month and contained three articles with engraved, hand-coloured illustrations. Three thousand copies were produced and sold, needing a team of thirty people to colour them and prepare them for publication. This format was much more successful. The more colourful garden plants illustrated attracted a wider audience than wild flowers and the price was also more attractive. After William Curtis' death, his nephew Samuel Curtis took over the Magazine. Later it was taken under the wing of the Royal Botanic Gardens, Kew, and it has been associated with Kew since then.

During the 19th and early 20th centuries, when many new plants from all over the world were introduced to cultivation, illustration in the Magazine was an ideal way to record the new introductions and make them known to a wider public. The original format proved to be acceptable for the purpose and it is still largely the same today, with the addition of articles on plant-related themes such as conservation, taxonomic studies, expeditions and historical information about plant collecting. There are now normally four parts a year, each with six illustrations produced by modern printing techniques and also published online. As a whole work in many volumes, it is a useful source of information for gardeners, horticulturalists and botanists.

Because of the success of this format, efforts are made to keep to this as far as possible. The size of the page is almost the same as in 1787 so that when bound, the volumes are a similar size. Illustrations are always drawn from a living specimen and if the whole plant is too big, a significant part of the illustration has to be life size. Accuracy of size, shape and colour are more important than composition and the image tries to convey the natural character of the plant. Extra information about the structure and floral details can be included in line drawings to give as complete an account as possible. The strictness and simplicity of the house style of *Curtis's Botanical Magazine* helps to maintain a high standard of botanical illustration and it has provided inspiration to generations of botanical artists.

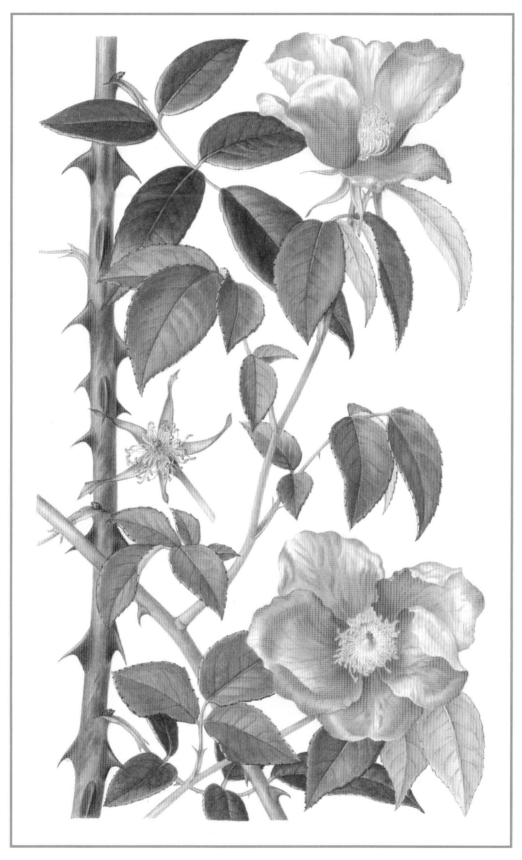

Rosa chinensis forma spontanea Plate 539, Vol. 22 (4), 2005

This vigorous wild rose from North West China is probably one of the ancestors of modern garden roses.

Corydalis flexuosa Plate 332, Vol. 15 (1), 1998

This pretty plant from Western Sichuan China, has become very popular in cultivation and various cultivars are available from nurseries. A tall form and a smaller, low-growing form are illustrated here.

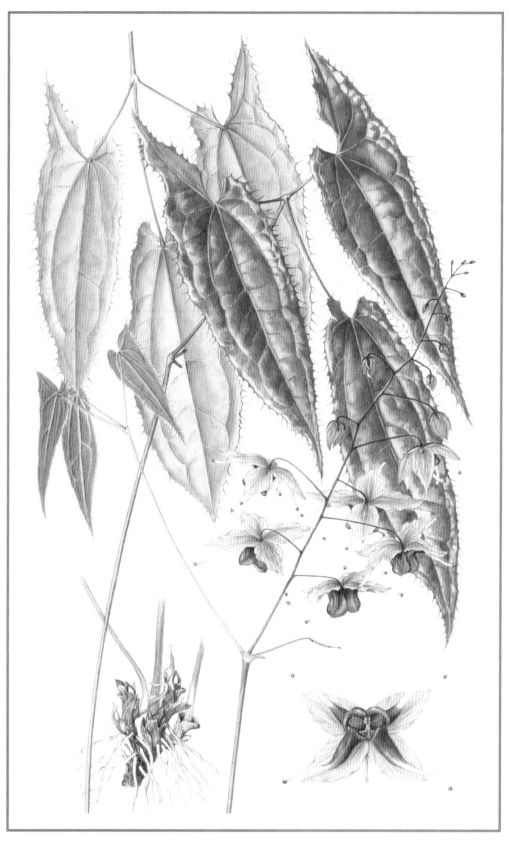

Epimedium stearnii Plate 713, Vol. 28 (3), 2011

One of the many beautiful new species of *Epimedium* recently introduced into cultivation from Western China. Many are not difficult to cultivate and are useful plants for shady places. A monograph of the genus by the eminent botanist W. T. Stearn was published in 1999 and this plant is named in his honour.

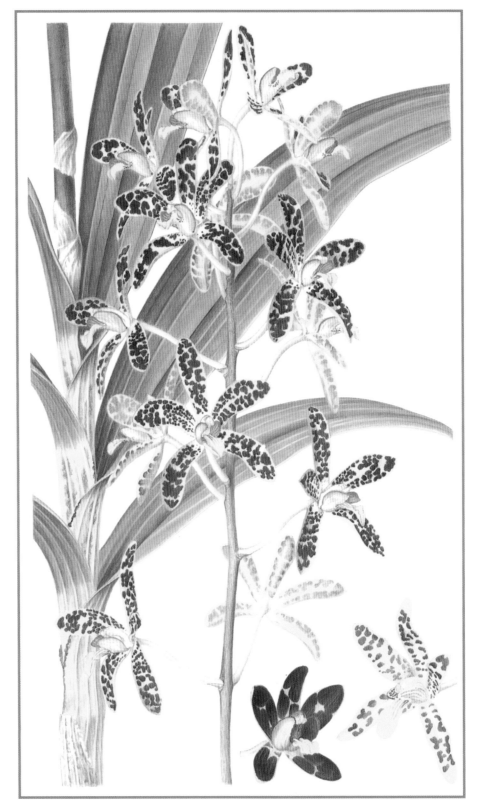

Ansellia africana Plate 216, Vol.10 (1), 1993

Many orchids have been illustrated in *Curtis's* because of the great popularity of the genus. This striking epiphytic orchid comes from tropical Africa but is now not common because of collecting. Various colour forms occur of which three are illustrated. It is not clear whether these are variants of one species or whether they should be separated into three species.

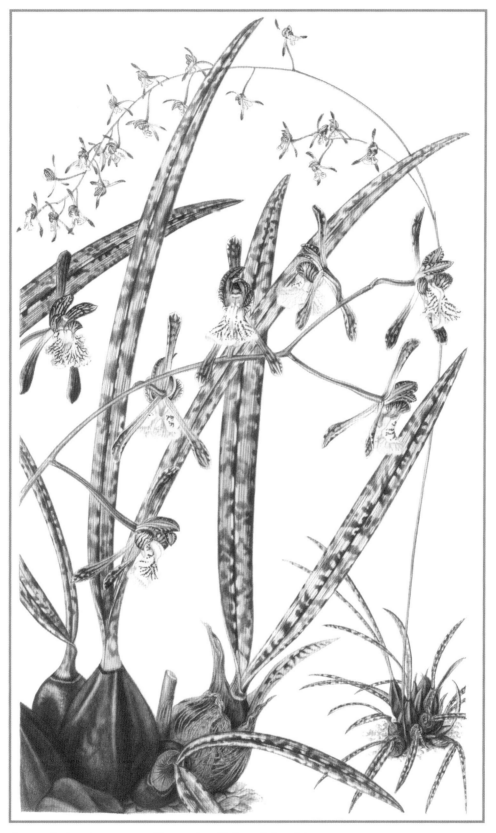

Oeceoclades decaryana Plate 405, Vol.18 (1), 2001

The unusual mottled foliage of this orchid from Madagascar makes it difficult to notice in the xerophytic habitat where it grows. A flower and leaf of a form with denser brown markings is shown and a habit drawing at a quarter of its natural size is included. The species is also found on mainland Africa.

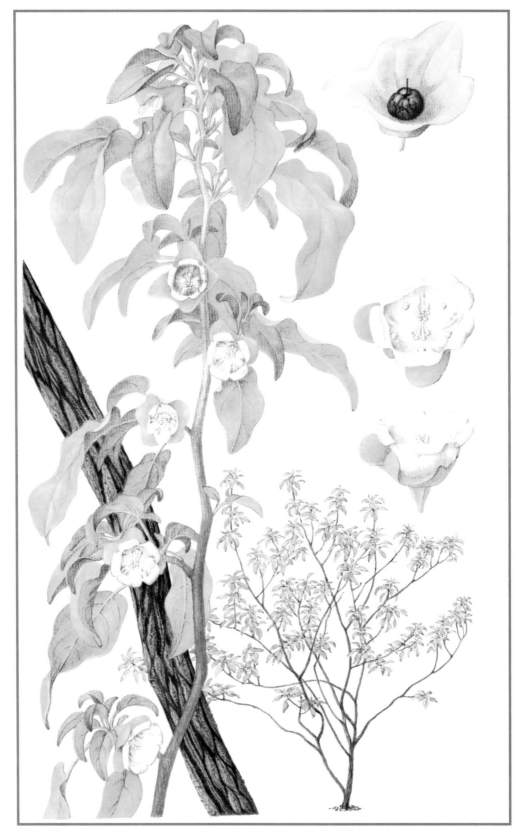

Melissia begoniifolia Plate 602, Vol. 24 (2,) 2007

The flora of the remote island of St Helena has been badly decimated by goats since it was first visited and this plant, known as St Helena Boxwood, was thought to be extinct until one plant was found in 1998. Since then many plants have been propagated from seed from this one plant.

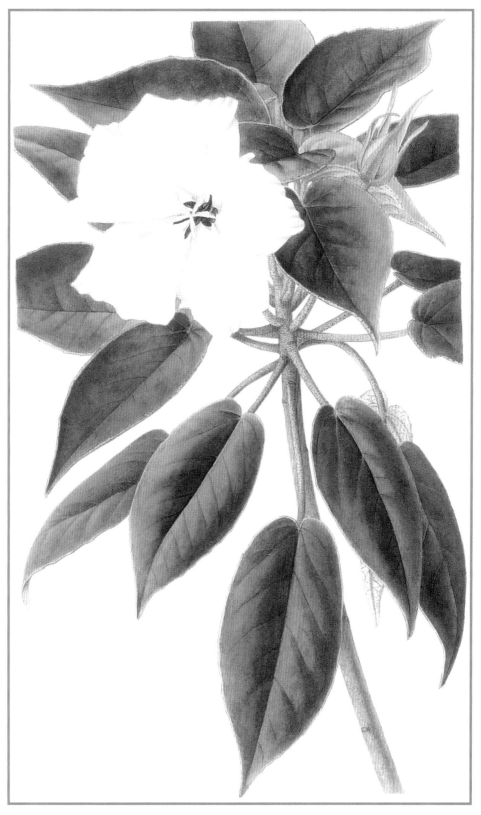

Trochetiopsis ebenus Plate 334, Vol. 15 (1), 1998

This tree, known as St Helena Ebony, was thought to have become extinct by 1850. It was rediscovered growing on a cliff in 1981, cuttings were taken and by 1986 two thousand plants had been raised on St Helena and were reintroduced to the wild and to gardens on the island. The plant illustrated is growing at Kew.

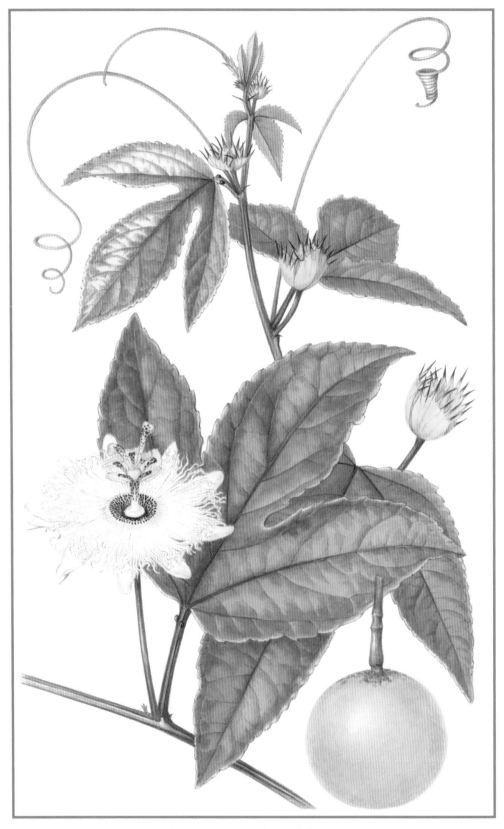

Passiflora edulis forma albida Plate 779, Vol.31(1), 2014

This *Passiflora* was found in an area north-east of São Paulo and is a golden fruited variety of the well-known passion fruit known in Brazil as *maracujá*. It may prove useful in improving disease resistance in the cultivated strains of *Passiflora edulis*.

Cocos nucifera Plate 355, Vol.16 (1), 1999

Some economic plants of special interest have been illustrated in the Magazine. This 2m (2yd 7in) tall specimen of the dwarf Malay golden coconut flowered and fruited in the Palm House at Kew after hand pollination. Drawings were made in situ in a sketchbook and photographs were taken. A photocopier was used to reduce the drawings to a suitable size for the illustration.

Phaenocoma prolifera Plate 289, Vol. 13 (2), 1996

The unusual and diverse flora of South Africa provides many desirable garden plants, although many are not frost hardy. This shrub is found in the 'fynbos' type of vegetation in Cape Province, which consists of grass and low-growing shrubs up to 3m (3yd 10in) tall.

Protea aurea subsp. aurea Plate 256, Vol. 11 (4), 1994

An attractive shrub or small tree which is found in the coastal mountains of the southern Cape. It is easy to cultivate under glass and this plant flowered when only one year old.

Eupomatia laurina Plate 591, Vol. 24 (3), 2007

Introduction to cultivation provides an opportunity for botanical study. This shrub from Australia and New Guinea may not be of horticultural merit, but it is botanically unusual. The flower buds have a cap, or calyptra, which detaches and falls off when the flowers open. In the morning, the stigmas are receptive, but the stamens only shed their pollen in the evening. A type of small beetle (Elleschodes) has been observed as the only pollinator.

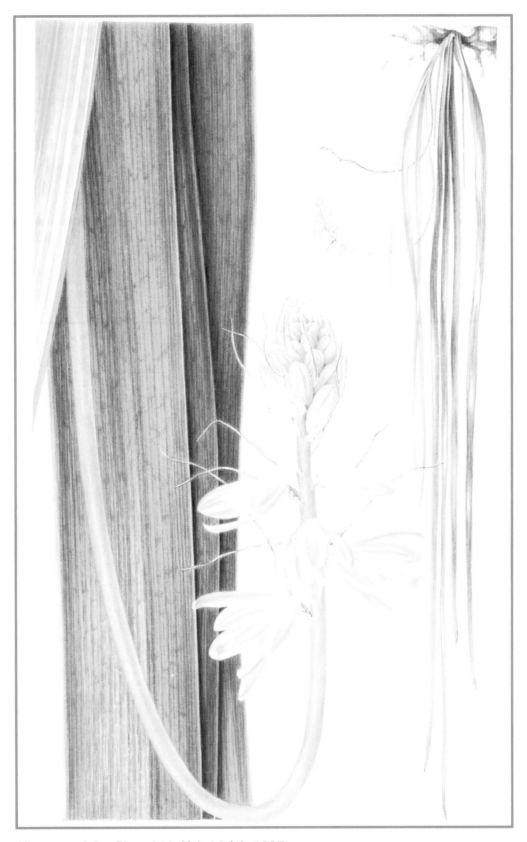

Albuca pendula Plate 312, Vol. 14 (1), 1997

A very rare bulbous species from South-West Saudi Arabia, which was discovered growing on rocky ledges in a narrow ravine in the mountains near the border with Yemen. Its leaves hang down and can grow up to 2m (2yd 7in) long, but the inflorescence curves up towards the light so that the flowers orientate normally. It behaves the same way in cultivation.

Designing a plate for *Curtis's Botanical Magazine*

It is a challenge to illustrate a large plant, such as this giant Sow Thistle from Tenerife, in the narrow format of the Magazine. In order to include several stages in this plant's growth, preliminary drawings were made in a sketchbook. The plant has a short, woody trunk and loses its leaves in winter.

Sonchus acaulis Plate 559 Vol. 23 (2) 2006

The colour plate shows part of the inflorescence, some seed heads and the apex of a leaf.

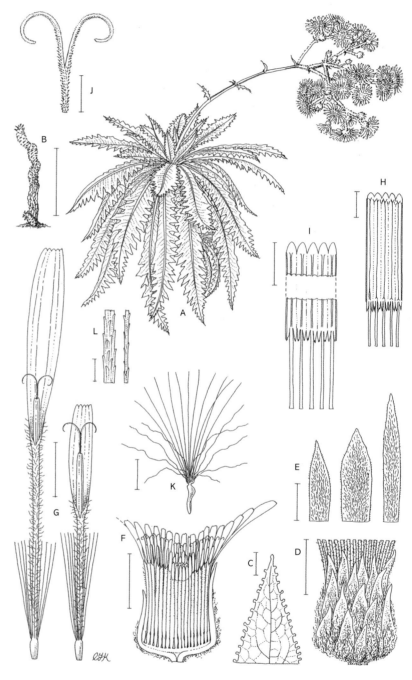

A: habit sketch of flowering plant; B: leafless overwintering trunk; C: apex of leaf lobe; D: capitulum; E: outer (left), middle and inner phyllaries; F: longitudinal section of capitulum; G: floret from margin (left) and centre of capitulum; H: anther cylinder opened out; I: anther cylinder; J: style arms; K: achene and pappus (immature); L: detail of inner (right) and outer (left) pappus setae.

Bar scales:- A,B = 50cm, C,H,I,J = 1mm; D,F = 10mm, E,G = 5mm, K = 2mm, L = 0.1mm

A sketchbook page of preliminary drawings for the colour plate and
line drawing of *Sonchus acaulis*.

Trees

Although it would seem that a photograph of a tree would be much better for identification, there are some advantages to a painting or drawing. Trees are often surrounded by other trees and buildings or they may be in situations which make it difficult to get a good photograph. In this case, a drawing made with the help of photographs taken from different angles may give a better result.

From a less botanical point of view, trees are important landmarks and may be of historical interest. There may be favourite neighbourhood trees which are a part of local life and which would make good subjects for paintings and drawings. They are worth looking at carefully, even if they have been shaped and pruned, so that records of them remain if they are cut down or damaged by a storm.

The sheer size and amount of detail is daunting to begin with. Where does one start, and how much detail should be included? It is better not to work solely from a photograph, but a good one is definitely a help, because although one may begin by drawing outside, neatness and fine finishing are best done indoors. Making a drawing from a good photograph is a way to start. Once the problems of detail and texture have been studied using a photograph, drawing outside from life may seem less difficult because one knows what to look for and put down on paper.

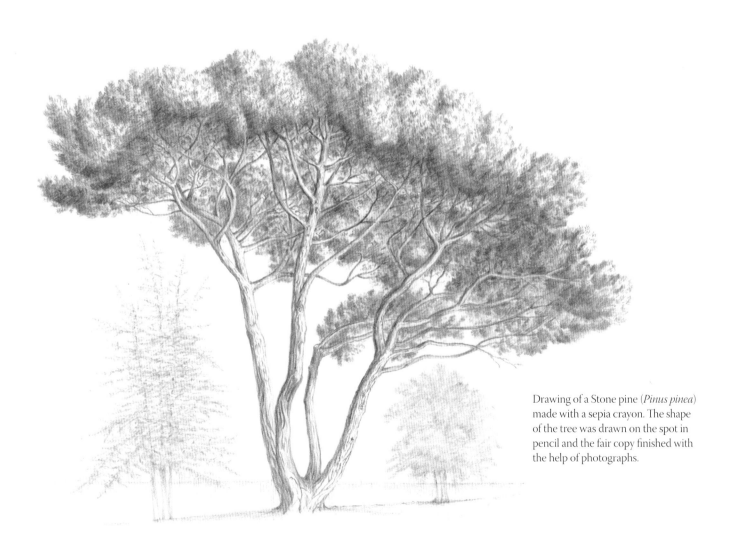

Drawing of a Stone pine (*Pinus pinea*) made with a sepia crayon. The shape of the tree was drawn on the spot in pencil and the fair copy finished with the help of photographs.

Drawing materials

A drawing tool which can come to a point is needed for fine details, but for shading, something less sharp may be more effective. Top of the list for convenience is an ordinary graphite pencil. It can be used with a point for detail or on its side for shading, and it will work outside if the paper gets damp in rainy weather. A graphite stick with a blunt point may be useful for shading. Water-soluble crayons are a possibility if colour is wanted, but the non water-soluble type will not work if the paper gets damp when working outside. It is worth experimenting with other tools such as a fountain pen, dip pen, fine fibre tip pen and ballpoint pen, to find ways of creating different effects and textures, appropriate to the different types of tree.

Drawing trees from life outside

If at all possible, make a drawing from life as a foundation for an image of a tree. The end result is more likely to convey a lively impression.

The rough sketch for the horse chestnut tree shown below took only about half an hour on a fine summer evening. I took photographs from where I was sitting to use as reference, but as a foundation for the drawing, I traced my sketch. I was reasonably sure it was accurate, as I had made careful measurements. I worked on A4 (11½ x 8½in) cartridge paper using an HB clutch pencil and an HB graphite stick to make shadow areas. The fair copy was drawn on Fabriano 300gsm (140lb) HP (smooth) watercolour paper.

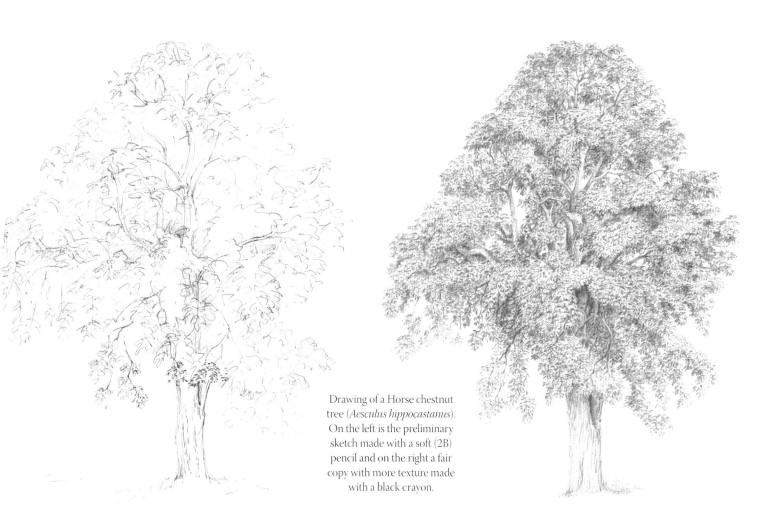

Drawing of a Horse chestnut tree (*Aesculus hippocastanus*). On the left is the preliminary sketch made with a soft (2B) pencil and on the right a fair copy with more texture made with a black crayon.

Drawing from a photograph

- Choose your viewpoint and take a number of photographs of the tree with different exposures. Notice the edge against the sky and whether you can see the smallest twigs. Usually one needs at least one photograph to show the shape well and others to show details of the leaves and smaller branches. A lot depends on the weather: whether it is sunny or cloudy, and how much contrast there is.

- Choose the photograph which you like best for the general shape and print it at a suitable size to show the most important branches, trunk and some detail.

- Make a tracing of the outline shape, trunk, main branches and masses of foliage, with any features that will serve as location places in the drawing.

- Decide how big you would like the artwork to be, depending on whether it is to be a printed illustration or a picture for exhibition.

- Photocopy the tracing to the size you want.

- Trace the photocopy and transfer it to the paper for the fair copy.

- At this stage you will need to stop and make some experiments in your sketchbook to find what medium you are going to use and how you are going to portray the foliage or the twigs if it is a deciduous tree in winter. This is important to get right and makes a lot of difference as to whether it is recognisable as a species or not. Choose a small portion of the tree and draw it in pencil at a scale at which the individual leaves are visible. Notice any characteristic features, about the angle at which the leaves are held, the length of the petiole (leaf stalk) and the shapes of sprays of foliage, which help to identify the tree.

- Make another experiment of part of the tree at the size of the fair copy to find how to portray the texture at the reduced scale.

- Now you can work on the fair copy and complete it using your reference photographs and visits to the actual tree if possible. Work over the whole drawing lightly at first, adding more tone in stages. If at any stage there is a doubt about how to proceed, make a trial on one of your experimental sketches before working on the fair copy.

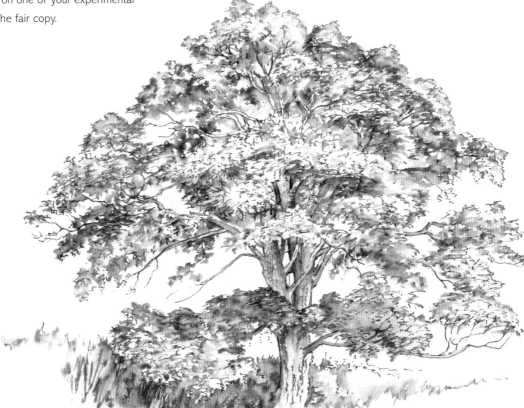

This sketch of a sycamore tree (*Acer pseudoplatanus*) was drawn with a fountain pen, using a wet brush to soften the lines and add tonal effects.

Advice for beginners

The easiest subjects for beginners to draw and paint are those which last long enough to allow work at a leisurely pace. Those who are new to drawing and painting must feel free to start again if the first version is not successful. Out of all the plants to choose from, select something with a shape which is simple to draw, such as the tulip below, and not too large. Tulips are easily available and they last well in water. Evergreen leaves are also useful for the same reason. Note that Minimum materials for beginners are recommended on page 13.

Leaf rubbings

This is an easy way to make an impression of the venation of a leaf which can be used as the basis for a drawing. It avoids spending time on making a drawing from life, however its possibilities are limited and it is only recommended as an exercise.

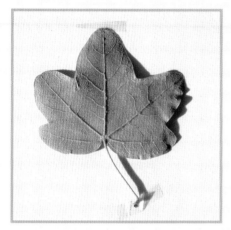

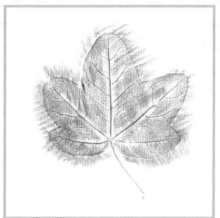

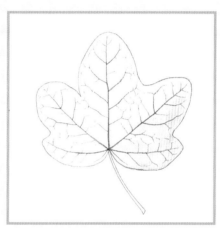

1 Attach the leaf (*Acer campestre*) face down to a base, such as a piece of card, with sticky tape.

2 Cover the leaf with thin paper, such as layout paper, and attach it so that it does not move, then with a B pencil, spread graphite across the leaf, pressing hard enough for an impression of the venation to show on the paper.

3 Remove the paper with the impression and trace and transfer it (see Transferring the drawing, page 34) onto watercolour or line drawing paper. You can now make a fair copy in pencil, which can be finished either in watercolour or pen and ink.

Three stages in a painting of *Tulipa cv. 'Ballerina'*

The pencil drawing was made on cartridge paper and then transferred to watercolour paper. The outlines and texture of the petals were painted with a fine brush using scarlet lake watercolour. The final colour consists of washes of cadmium orange, scarlet lake and permanent rose.

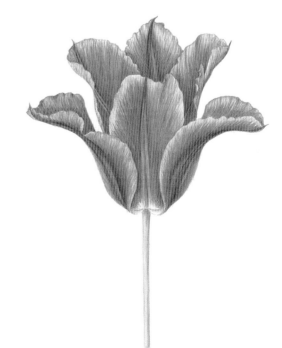

Botanical glossary

Actinomorphic Radially symmetrical, with two or more planes of symmetry

Anther Part of stamen containing pollen

Apex The furthest point from the base of a stem or leaf

Areole Area of cactus stem where leaves and spines originate

Biodiversity Spectrum of all forms of life

Concave With outline or surface curving inwards

Cultivar A cultivated plant specially selected and named

Description In taxonomy, words and measurements which describe a plant referred to under a Latin name

Ellipse A regular oval shape

Epiphytic Plants which naturally grow on other plants such as trees rather than on the ground

Fertile Of stamen, containing viable pollen: of fruit, containing viable seeds

Flowering plants Plants which have enclosed ovules which develop into seeds

Growing point Area where growth takes place by cell division

Habit General appearance or typical growth form of a plant

Inflorescence Flowers grouped together on a stem

Lamina Thin flat area of leaf or petal

Leaf serrations Jagged leaf margin

Locules Spaces within an ovary containing ovules

Midrib The central supporting vein of a leaf

Nodes Distinct junctions between sections of a stem

Oblique Seen sideways, from an angle

Ovary Part of flower with ovules which will become seeds

Parallel Of venation: veins run parallel to each other along the length of a leaf

Pedicel Stalk of a flower

Perianth Petals and sepals of a flower

Perspective Appearance of a solid object projected onto a flat plane

Petals Inner whorl of perianth

Petiole Stalk of a leaf

Photosynthesis The process by which light energy is converted into plant growth

Phyllotaxis The arrangement of leaves on a stem

Plant press A bundle of blotting paper tightly strapped between two stiff slatted covers in which to press and dry plants

Pseudobulb A swollen stem which resembles a bulb

Reticulate Of venation: interconnecting veins running in various directions

Rib Raised ridge of a cactus stem

Sepals Outer whorl of perianth

Specimen Individual chosen as an example

Stamen Pollen-bearing part of flower

Stigma Area of style receptive to pollen

Style Extension of the ovary with stigma to receive pollen

Succulents Plants with swollen stems and/or leaves which store water

Symmetry Division of a shape into similar parts by a plane or a line

Taxonomy In botany, the study of names and categories by which types of plants are referred to

Tepals Sepals and petals if only one whorl

Venation The pattern of veins in a leaf

Whorl Arrangement of parts attached in one place around a stem

Xerophytic Plants which occur naturally in dry habitats and deserts

Zygomorphic With only one plane of symmetry, or folds in half in only one place

Artistic glossary

Acrylic Water-soluble paint in an acrylic medium

Aerial perspective Objects further away are shown paler than those close at hand

Artists' licence Artists' freedom to draw in a way which suits a composition

Bar scale A small drawn line of a stated size indicating the scale of a drawing

Binocular Microscope with two eyepieces enabling use of both eyes to view objects

Block Watercolour or cartridge paper glued to a backing sheet on one or three sides

Burnisher Tool used in gilding with a smooth, blunt, agate tip

Camera lucida A microscope attachment which enables an image to be projected onto paper for drawing

Caption Words providing information about an illustration

Clutch pencil Propelling pencil

Composition Consciously thought out design

Cross-hatching Shading with crossed lines

Diagonals Lines running from corner to corner of a rectangle

Dip pen A nib in a holder with no internal ink reservoir

Drawing Representation using lines or lines with colour

Emery paper Fine sandpaper, as used for smoothing surfaces

Eyepieces Lenses at the top of a microscope, close to the eyes of the viewer

Foreshortening Dimension appearing shorter to the viewer due to recession

Gouache Water-based paint, either transparent or opaque

Graticule A piece of glass inserted in a microscope eyepiece with a grid or rule for measuring objects

Half-up Drawn one and a half times life size

Hatching Shading with lines

Highlight Area of reflected light

Hue Type of colour in spectrum

Lightfast Does not change with exposure to light

Life-size Natural size; the same size in two dimensions on paper as in reality

Magnification Enlargement to bigger than life-size

Mapping pen A type of small dip pen with a fine nib

Monochrome A drawing or painting using only one colour

Monocular Microscope with only one eyepiece so objects can only be viewed with one eye

Objective The part of a microscope close to the object viewed

Painting Representation using monochrome or coloured surfaces

Plane A two-dimensional surface

Scale Dimensions relative to reality

Scale bar *see* Bar scale

Stipple A small mark made with brush or pen

Symmetry Division of an object into similar parts by a line or plane

Three-dimensional Solid, defined by height, width and depth

Tint Type of colour; admixture

Tone Quality of colour from light to dark

Two-dimensional Flat, defined by height and width

Wash A solution of diluted ink or paint

Watercolour Transparent water-based paint

Index

Bibliography

These are the books I have found useful. I cannot guarantee that all will remain in print.

Publications mentioned in the text:

Curtis's Botanical Magazine (1787–), Wiley Blackwell, Oxford

Curtis's Botanical Magazine Monograph Series:
 Stearn, W.T. 2002: *The Genus Epimedium*, Royal Botanic Gardens, Kew

 Taylor, N.P. 1985: *The Genus Echinocereus*, Royal Botanic Gardens, Kew in association with Collingridge and Timber Press, USA

 Upson, T. and Andrews, S. 2004: *The Genus Lavandula*, Royal Botanic Gardens, Kew

Flora of Tropical East Africa,1952– 2012, Royal Botanic Gardens, Kew. An enormous work in many parts with line drawings by many different artists.

Curtis, William, 1746–1799: *Flora Londinensis.* Published in 72 parts of folio size, each with 6 illustrations. Printed for George Graves, by Richard and Arthur Taylor, 1817–1828. Illustrations of wild flowers found within 10 miles of the centre of London.

Yeoman, Guy, 1989: *Africa's Mountains of the Moon*, Elm Tree Books, London. Has12 illustrations of Ruwenzori wild flowers by Christabel King.

Historical reference:

Blunt, W. and Stearn, W.T. 1994: *The Art of Botanical Illustration,* Antique Collectors Club, Woodbridge, in association with the Royal Botanic Gardens, Kew. Has many illustrations.

Morton, A.G. 1981 *History of Botanical Science,* Academic Press, London, New York

Example illustrations:

Sherwood, Shirley, 1996: *Contemporary Botanical Artists: The Shirley Sherwood Collection*, Weidenfeld & Nicolson, London

Sherwood, Shirley, 2005: *A New Flowering: 1,000 years of Botanical Art*, Ashmolean Museum, Oxford

Sherwood, Shirley and Rix, Martyn 2008: *Treasures of Botanical Art*, Royal Botanic Gardens, Kew

Ross-Craig, Stella, 1979: *Drawings of British Plants*, Bell & Hyman, London. Definitive line drawings of the British flora.

Mabberley, D.J. 2000: *Arthur Harry Church: The Anatomy of Flowers*, Merrell Publishers and the Natural History Museum London. Examples of coloured dissection drawings.

Botany:

Heywood, V.H., Brummitt, R.K., Culham, A. and Seberg, O, 2007: *Flowering Plant Families of the World*, Royal Botanic Gardens, Kew and Firefly Books, Canada in N. America. For a classification of flowering plants.

Foreman, L. and Bridson, D. 1989: *The Herbarium Handbook*, 3rd Edition, Royal Botanic Gardens, Kew. A guide to herbarium techniques.

Beentje, Henk, with illustrations by Williamson, Juliet, 2010: *The Kew Plant Glossary: An illustrated dictionary of plant identification terms*, Royal Botanic Gardens, Kew. For the meanings of botanical terms.

For a complete list of all our books see
www.searchpress.com